# THE HUNTINGTON

## LIBRARY

## ART GALLERY

## BOTANICAL GARDENS

*Elizabeth Pomeroy*

Scala/Philip Wilson

*for James Thorpe*
DIRECTOR OF THE HUNTINGTON FROM 1966 TO 1983

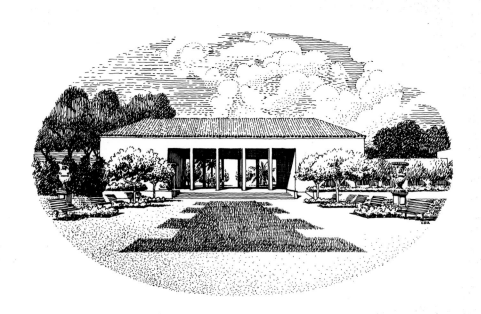

© 1983 Philip Wilson Publishers Ltd and
Summerfield Press Ltd

First published in 1983 by Philip Wilson
Publishers Ltd and Summerfield Press Ltd
Russell Chambers, Covent Garden, London WC2 8AA

Designed by Gillian Greenwood
Series Editor: Kathy Elgin

Produced by Scala Istituto Fotografico Editoriale, Firenze
Phototypeset by Modern Text Typesetting, Southend, Essex
Printed in Italy

ISBN 0 85667 210 6 (paperback)
ISBN 0 85667 211 4 (hardback)

Front cover: *Karl Friedrich Abel* by Thomas Gainsborough, R.A.
Back cover: The Moon Bridge in the Japanese Garden.

# Contents

# Acknowledgements

The author and publishers would like to express warm thanks to the following officers of the Huntington for their assistance: Daniel H. Woodward, Librarian; Robert R. Wark, Curator of the Art Collection; Myron Kimnach, Curator of the Botanical Gardens; and Suzanne W. Hull, Director of Administration and Public Services.

The photographs were taken by the Huntington staff, chiefly by Robert Schlosser. The old rose photograph (p.117) is by Leland Y. Lee.

An early stage in the development of the Desert Garden, *c.*1912.

# Introduction

The life of an institution may be greater than the sum of its parts. At the Huntington a pre-eminent library, a distinguished art collection, and a bounty of gardens make a combination unmatched anywhere. Each of the three areas contains a wealth of rarities for specialized study, and materials full of beauty and interest for the general visitor. Throughout the institution, human energies animate these collections and keep them alive in ever-changing ways.

The Library is the largest and most complete repository in the United States of source material on British and American civilization from the Middle Ages to 1850. For thousands of scholars over the years, it has been the *sine qua non*, the library which must be consulted before their research projects can be considered complete. Its holdings now include rare books, reference books, manuscripts, historic photographic prints and negatives, printed and manuscript maps, and supporting collections of pictorial prints and drawings, music, and ephemera. Altogether there are about six million items. Special strengths are British historical records, the earliest English printed books, extensive holdings on the American Revolution and Civil War, Middle English literary manuscripts, and major archives of such modern authors as Jack London and Wallace Stevens. Among the treasures for research and exhibition are the Ellesmere manuscript of Chaucer's *Canterbury Tales*, a fine Gutenberg Bible on vellum, the elephant folio edition of Audubon's *Birds of America*, and an unparalleled set of early quartos and folios of Shakespeare.

The Art Gallery houses one of the finest specialized collections in the country of British and French art of the eighteenth and nineteenth centuries. Its perspective of the British art of that period—paintings, drawings, sculpture, silver, miniature portraits, ceramics, and furniture—cannot be surpassed outside London. On view are such world-famous paintings as Gainsborough's *Blue Boy*, Lawrence's *Pinkie*, Reynolds' *Mrs Siddons as the Tragic Muse*, and Constable's *View on the Stour*. A strong supplementary group of Continental paintings and many thousands of prints and drawings make up a very considerable collection which is seen in rotating exhibitions. A supporting art reference library aids the work of scholars. The collections are displayed in the elegant domestic setting of a stately mansion of Beaux Arts style, formerly the Huntington residence.

Surrounding the Library and Art Gallery buildings, the Botanical Gardens cover about 130 acres of widely varied terrain. A dozen specialized gardens, some the finest of their kind in the world, are arranged within a parklike landscape of rolling lawns. Some of the areas feature a single family of plants, while others emphasize a single environment or culture. Among the most remarkable are the Desert Garden (the largest outdoor collection of desert plants in the world); the Japanese Garden, with its traditional house and Zen garden; the Rose Garden, showing the history of the rose over two thousand years; one of the largest camellia collections in the world; Australian, Subtropical, Palm, Jungle and Herb Gardens; and the Lily Ponds. Altogether more than 15,000 different kinds of plants are found here, offering year-round displays of beauty.

The present life of the Huntington may be considered in two parts: that of the research institution and that of the public institution. The former provides resources for about fifteen hundred scholars each year, working behind the scenes,

scanning rare books, manuscripts, photographs, and art materials. Staff members actively pursue research in all areas, and other readers come from all over the world. The Publications Department publishes books and a quarterly journal to disseminate studies undertaken at the Huntington. Seminars and conferences further extend these findings and reinforce the informal alliance with dozens of colleges and universities. The acquisition of rare books and manuscripts, as well as art and botanical materials, continues vigorously, with current reference works keeping the collections up to date for study. A modern Conservation Center performs minor miracles in rescuing and preserving fragile objects to safeguard the holdings for future generations.

A look at the research activity at the Huntington reveals an almost incredible variety. On any given day, scholars in the Library are preparing, say, an index of Elizabethan verse, a critical biography of the American novelist Nathaniel Hawthorne, a study of women and the Western frontier experience, and editions of a dozen major authors. Others comb the vast collections of British historical manuscripts or search the photograph archives for visual answers to their questions. In the Art Gallery, other scholars may be at work on British landscape drawings or illustrations for Shakespeare's plays: a specialized catalog may be being made of the silver collection, or of portrait drawings. Meanwhile, members of the botanical staff depart on their annual expedition to Mexico in search of new plant varieties; a shipment of rare bamboo from South China arrives to be held for the required quarantine and study; and herbarium specimens of dried plants are mailed away in an exchange project with another botanical garden. Much of this research will subsequently appear in specialized articles or books, some in pamphlets or talks for the general public – gradually the work filters through to an ever-widening and diverse audience.

Coexisting with this is the public institution, different in character but still offering learning and inspiration to people of all ages. Both permanent and changing exhibitions, showing the whole scope of the collections, are always on view in the Library and Art Gallery, and the Gardens are themselves a living museum with new highlights in every season. Half a million visitors come each year, from all backgrounds and from all parts of the world. For them there are tours, talks, extensive school programs, special educational activities and publications, and performances of music, drama, and dance relating to the collections. Volunteer opportunities provide exciting experience for many in teaching, guiding, or work ranging from book conservation to plant propagation.

A look at another typical day shows the scope of activities available to the public. A school class may come to study the development of printing; another group, outdoors, compares plants in desert and jungle environments. The daily schedule may include a tour for the blind and numerous senior citizens groups who will be guided through the exhibits and grounds. A new display opens in the Library to illustrate the early history of science, while the afternoon may offer a poetry reading, a talk on William Blake, or a harpsichord recital. The large, new Pavilion building, with its visitors' center, orientation displays and meeting rooms, promises even more expansion in the range of activities in the future.

Ultimately, the vitality of any complex institution can never quite be explained. New links between its parts are constantly being forged and stimulating ideas for research or reflection. Walking out of the Art Gallery, with its cool rain-washed landscapes by Constable, the Curator says, "Let me show you our modern art." It is the Desert Garden, with other-worldly shapes and textures of plants arranged in fascinating compositions. Elsewhere in the grounds the Herb Garden, with its background of history and folklore, sends visitors to the Library exhibitions in search of the herbals and natural history volumes that illuminate the past. There, one is back in the realm of the graphic and visual arts, amongst decorated medieval

manuscripts and countless designs of type, texts, maps, and illustrations. It is surely this combination of various and constantly-changing activity, set against the timelessness of the collections, that gives the Huntington its unique appeal, and makes it, as a center of both learning and pleasure, unlike any other in the world.

Henry E. Huntington, *c*.1904.

# A Brief History

The story begins in 1892 in Southern California, in what seemed then, approaching the turn of the century, a specially-favored land. In that year Mr Henry Edwards Huntington, a successful man of commerce, paid his first visit to the San Marino Ranch some ten miles northeast of the center of Los Angeles. The place was an ample spread of six hundred acres, planted to citrus orchards interspersed with native oaks and grassy hillsides. Its owner was one J. DeBarth Shorb. Huntington, then forty-two years old, was captivated by the promise of that region, thinly settled but beginning to stir, and although business took him elsewhere, he was convinced that Southern California, with so many natural advantages, had an unbounded future for commercial and cultural development. Then, with Shorb's death in 1903, the opportunity waited to be seized: Huntington bought the San Marino Ranch.

A native of Oneonta, New York, Huntington had early turned his energies to the railroad industry. His business career was marked by the same combination of insight and vigorous action that later distinguished his collecting. He worked for many years with his uncle, Collis P. Huntington, in various capacities, finally operating between New York and California to manage the Southern Pacific and other Huntington interests. After his uncle's death in 1900, "H.E." (as he was known in the railroad world) made his base in Los Angeles and began developing the remarkable Pacific Electric line, the largest inter-urban system known at that time. Its thousand miles of tracks opened up the farthest corners of the "Orange Empire" to growth and material progress. A generous and public-spirited citizen, Huntington lent his hand to many civic causes and improvements as the region flourished.

By 1908, close to the age of sixty, Huntington had decided to retire in order to devote more time to some interests of long standing. Two programs received the main force of his attention: the development of his beloved Ranch, and an astonishing surge in his collecting of books and art.

Huntington had always enjoyed books and enjoyed acquiring them. His first purchases, not surprisingly, were editions of favorite authors; later, he turned to examples of fine printing, illustration, and handsome bindings. His New York home was already full of books when, in 1910, his activity took a dramatic turn. Having determined upon English and American history and literature as a focus for his collecting, he decided to limit his purchases to first, early, and rare editions, and to manuscripts. Soon he began to exercise his own individual method in buying: he acquired complete libraries *en bloc*, deciding quickly, spending generously. Book-sellers were attracted in quantity as he poured energy and money into this market. Such rich collections as those of E. Dwight Church, Robert Hoe (including the Gutenberg Bible), Alfred H. Huth of London, and the Britwell Court Library came into his possession; later the splendid early English books of Beverly Chew, the Kemble-Devonshire collection of English plays, and the Bridgewater House Library, with its glorious Ellesmere manuscript of Chaucer's *Canterbury Tales*. Each of these units represented a lifetime or more of collecting, brought at one swoop under Mr Huntington's roof. Dr A.S.W. Rosenbach was a principal source of rare books during these exciting years.

The growth of the art collection proceeded more slowly toward its chosen focus. Huntington had bought pictures (mostly prints) over the years for domestic

enjoyment, but he began vigorous collecting only after 1907, when his efforts were spurred by another remarkable and energetic personality entering the picture: Arabella Huntington, widow of his uncle Collis. She had already gathered a great collection of paintings, including Rembrandt's *Aristotle with the bust of Homer*, in her New York residence, and after Henry's first marriage ended in divorce in 1906, she worked closely with him in a rush of art purchases. The earliest acquisitions were some Barbizon paintings – the usual choice of American millionaires at the time, but with the advent of the noted art dealer Joseph Duveen – a major figure in the drama thereafter – the collection took quite a different direction. In 1911 Henry acquired the great set of Beauvais tapestries designed by François Boucher, depicting elegant young men and women enjoying themselves in the country, several magnificent pieces of French eighteenth-century furniture, and three major portraits by Gainsborough. This last sale (and the correspondence attached to it) seemed to settle the future emphasis of the collection; it was to be British art of the Georgian period, and especially the great portraits. French eighteenth-century decorative art entered in a strong supporting role. But the precise reasons for these choices remain to this day a mystery not explained by any of the principal actors.

During this time the architects Myron Hunt and Elmer Grey were at work on a grand mansion in the Beaux Arts manner favored by prominent early-twentieth-

The Reading Room and Exhibition Hall in the Library, *c*.1927.

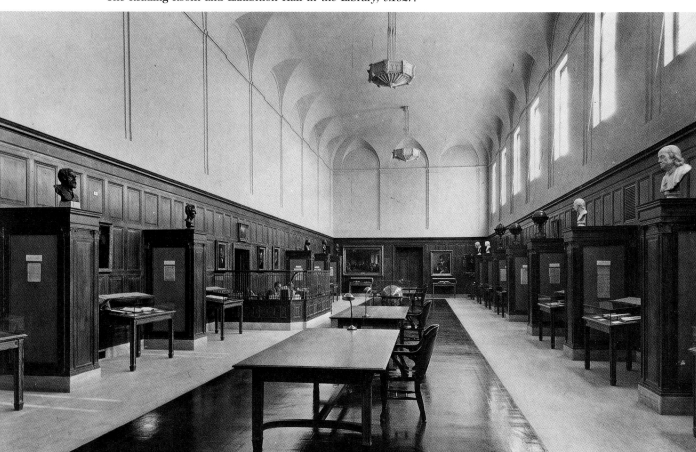

century Americans. It replaced the comparatively modest Victorian dwelling of J. DeBarth Shorb on a broad knoll at the Ranch. The house, finished in 1910, contained ample halls and walls for the burgeoning art collection. The rooms, modelled on French and English eighteenth-century interiors, were made in London and shipped to California for installation. In 1913 Henry and Arabella (who were about the same age) were married and soon after took up residence in their California home. This building, the present Art Gallery, was augmented in 1934 by the addition of the large Main Gallery wing.

The second major building of the present-day institution was created a decade later to house the books and manuscripts overflowing Huntington's New York residence. The Library was built to a classical design, its stately columns and proportions harmonizing with the nearby mansion. It was in the form of the letter E and included a combination exhibition and reading room and wings for workrooms and book vault. In 1920 the building was complete and the collections, already famous, were transferred from New York to San Marino – far afield, it then seemed, from the centers of intellectual life on the East Coast.

In the meantime, the botanical gardens had been coming to life in yet a different way. One of the joys of the Ranch, to Huntington, was always the generous climate of sunshine and mild temperatures, in which any plant seemed eager to grow. The

The loggia of the Huntington residence, used as an outdoor living room, c.1918.

spirit of experiment drove him: he wanted to see what varieties of unusual plants and trees could be made to flourish here (in fact, almost everything they tried did) and which could be made commercially profitable or ornamentally useful. There was the spirit of friendly competition, too, combined with the instincts of a collector: he wanted rare specimens and more of them than anyone else had. The Ranch was a business but also a constant source of satisfaction and pleasure.

Huntington's right hand in developing the gardens was William Hertrich, who came as a young man in 1904 and was closely involved, first as Superintendant, then as advisor, for sixty-two years until his death. Together, he and Huntington shaped, collected, studied details, and created broad and lovely effects. The Lily Ponds, the Palm Garden, and the Desert Garden were developed first, followed by the North Vista, the Rose Garden, the Cycad Collection, and the most extensive project: transforming a scrubby canyon, with its tangle of native vines, into a serene Japanese Garden. The grounds were becoming not only a choice setting for the library and art collections, but also a botanical display of absorbing interest in their own right.

The idea of the Huntington as an institution, as a gift to the public, was also taking shape during these years. Discussions had begun as early as 1906 with trusted advisors: how could the books and art best be left to benefit people and to serve researchers? Should they go to an existing organization? Be situated on the West Coast or the East? Be settled within a new, independent foundation endowed for their care and future use? Finally the latter course of action emerged as the clear choice, and the San Marino property the favored site.

Huntington's collections had seemed destined for the public good from the start. He felt he was only holding in trust these treasures, with a responsibility far greater than that of mere personal ownership. His rare books and manuscripts had always been available to scholars who needed them. The San Marino residence was ordered built with a reinforced second storey to allow its later transformation into a public gallery. It remained only to establish formally this gift to future generations.

On August 30, 1919, the founding indenture was signed, creating the institution of today with this stated purpose: "to promote and advance learning, the arts and sciences, and to promote the public welfare by founding, endowing and having maintained a library, art gallery, museum and park." The institution was to be governed by an independent Board of five Trustees, who have been self-perpetuating to the present day. A revision of the indenture in 1926 honed even more sharply the mission of the new Huntington: it was "to prosecute and encourage study and research in original sources . . .and generally to conduct an institution of educational value." The sails were set for the future.

In the last years of his life Huntington continued to buy and to build. At his wife's death in 1924 he established the Arabella D. Huntington Memorial, an exhibit of her favorite Renaissance paintings and French decorative arts. Among his last library purchases were two vast collections of British family papers: the Stowe and the Hastings-Huntingdon collections. Art acquisitions poured in, including the incomparable *Pinkie*, bought just a month before his death. To the relief of his Trustees, Huntington planned for a final endowment to perpetuate his institution and its programs of research. This endowment today continues to provide an important part of the operating funds each year, augmented by generous, and essential, community support.

In May 1927, Huntington died in Philadelphia. His body was brought back to San Marino and buried beside that of his wife in the beautiful neo-classic mausoleum designed by John Russell Pope at the highest point of the Ranch, where the orange groves meet the edge of the oak woodlands.

# THE LIBRARY

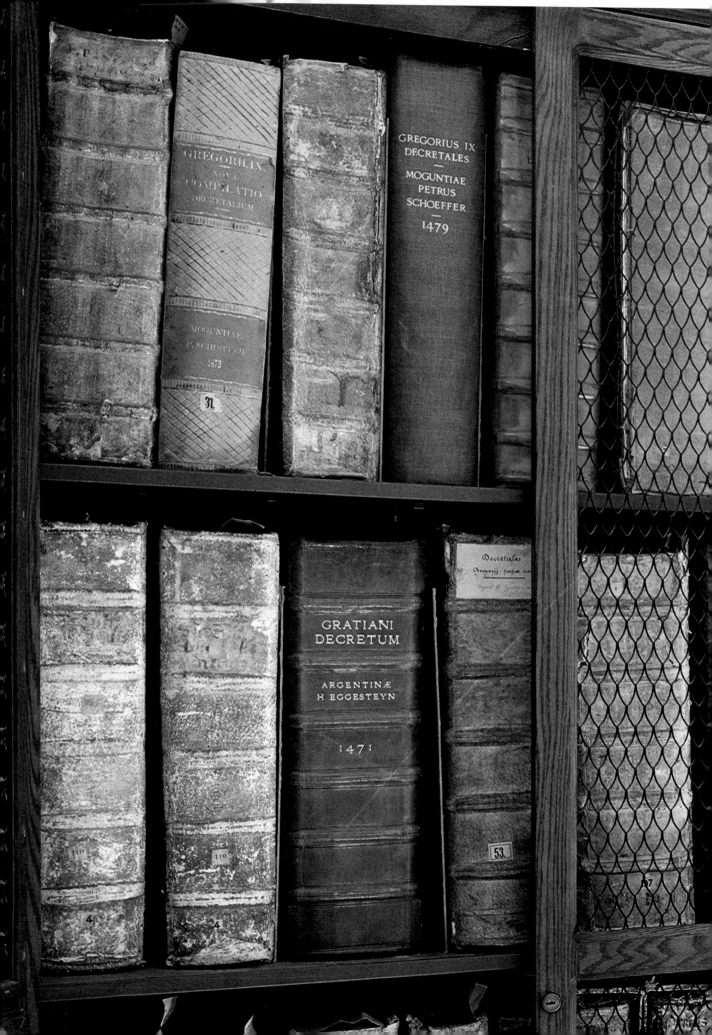

The Huntington Library shows the first glimpses of its character to the visitor in the splendid Exhibition Hall. Here, in a setting entirely refurbished and reopened to the public in 1977, about two hundred treasures from the collections are arranged in chronological display – rare books and manuscripts which trace the whole course of British and American civilization. As a panorama, they give an unsurpassed view of landmarks in our cultural history and of the energies of the human mind over nine centuries. As individual pieces, they offer on close observation the colorful splendor of medieval illuminations, curious detail in early maps, crowds of emblematic figures on Elizabethan title pages, or the manuscript revisions of a modern poet. There are 'signs and wonders' throughout the Hall.

The exhibits on view here are a representative sample of the great range and variety of the collections. Medieval manuscripts first make an extraordinarily vivid showing, highlighted by the Ellesmere volume of Chaucer's *Canterbury Tales*. This is perhaps the most famous of all English literary manuscripts, dating from *c*.1410 and decorated with a lifelike portrait of Chaucer and illustrations of the twenty-two pilgrims. Around it are many books and documents of the Middle Ages: the eleventh-century Bible of Bishop Gundulf, several of the Library's sixty-eight Books of Hours (so rich in colors and gold), the royal seals of several British Kings. Medieval literature appears in manuscripts of Boccaccio, William Langland, and the mystery plays of the Chester and Wakefield cycles.

The earliest printed books are a special area of strength and in fact lend their ambiance to the entire Hall. Shelved on a balcony around the walls are more than 10,000 volumes, mostly from the fifteenth century, monumental both in size and as landmarks in the early spread of learning. The centrepiece of this collection is the beautiful Gutenberg Bible, its two volumes printed on vellum about 1455, famed as the first book printed with movable type. The birth and development of printing may be traced in surrounding displays, which include two early wood-block books, the work of the first English printer William Caxton, and elegantly simple editions of the classics: Jenson's Pliny, and handsome volumes of Plato, Virgil, and Dante. The transition from manuscript hand to typeface makes a fascinating study both in grace and in power of communication.

Renaissance books are the fruit of this burgeoning of printing, and the Huntington Library holds an unparalleled collection. All the areas of sixteenth and seventeenth-century creativity are represented, including the great maps and geographies (Mercator's atlas, De Bry's *America*), major works of science (Vesalius, Harvey, Newton), profoundly influential religious texts (the Anglican Prayer Book of 1549, the King James Bible), and the arts of music and literature. Milton, Spenser, and Bunyan are here, as well as the great dramatists, Jonson, Marlowe, and others. Shakespeare is central, and the Huntington collection of early editions of his work is unsurpassed by any other library. The indispensable First Folio and a sheaf of rare quartos, including plays and poems, make a strong focal point in the Renaissance display.

Eighteenth-century Britain is richly documented in the Huntington holdings. First editions of the great fiction, poetry, and comedies of that age may be found, among them the works of Swift, Pope, and Fielding. Large manuscript collections, numbering thousands of pieces, reveal the life and spirit of the time: among them the Ellesmere papers, the Hastings, and the splendid Stowe collection – with nearly half a million items, the largest British family archive in America. A fascinating counterpoint to the literary and historical records in the Library is offered by the works in the Art Gallery – nowhere else, perhaps, can this complex period of time be studied with greater profit and pleasure.

British literature of the nineteenth century, Romantic and Victorian, appears in abundance, with the Huntington again holding most early editions of all the major

writers. Some choice manuscripts (Byron, Shelley, Trollope) join Dickens' serial *Pickwick Papers* and Thackeray's *Vanity Fair* with the author's drawings on display in the Exhibition Hall. From the earlier years of the century, the poems of William Blake, visions in words and illustration, are perennial favorites, complementing the Blake collection in the Art Gallery, where fifty-six paintings, drawings, and color prints by or attributed to him are preserved.

The settling of the British and others in the New World marked the beginning of a new society and this early American experience is vividly recorded in Huntington materials. Visitors see a striking exhibit chronicling three founding fathers of the United States: the manuscript of Benjamin Franklin's *Autobiography* in his own hand, letters and papers of George Washington, and the writings of Thomas Jefferson, with related maps. The Library's holdings of Colonial books are represented by John Smith's *Generall Historie of Virginia*, John Eliot's Bible in an Indian tongue, and other earliest printed books – among them natural history, music for psalm-singers, and the first law books.

Other volumes, manuscripts, and rare prints document the American Revolution, the drafting of the U.S. Constitution, and, in Noah Webster's *American Dictionary*, the shaping of a language. The Exhibition Hall can only hint at the Library's collections on the Westward Movement, which include pictorial records by Catlin, Bodmer, and Goldsborough Bruff, as well as dozens of manuscript journals detailing the excitement of the American frontier. The Civil War period comes alive through the first edition of *Uncle Tom's Cabin* by Stowe, and eloquent manuscript letters of Abraham Lincoln. The natural history of this country is treated in the imposing double-elephant folio of John James Audubon's *Birds of America*, whose great size and beautiful plates make a powerful impression on all who view it.

In the Exhibition Hall the foremost American writers appear in early editions, manuscript drafts, letters, and photographs. Poe, Whitman, and Emily Dickinson appear alongside the novelists, Hawthorne, Melville, Mark Twain, and Henry James. A special treasure is the holograph manuscript of Thoreau's *Walden*, which aptly illustrates the challenge and reward of the scholar: puzzling through the author's drafts and corrections, often in difficult handwriting, to reach an understanding of his creative process.

The Exhibition continues with the development of the American West, and especially California. Drawings, stagecoach schedules, early missionary records, and period fiction all reveal the life of the times. The discovery of gold in California, in 1848, with the resulting "gold fever" felt around the world, is vividly documented, along with the "rush" of American civilization to the western edge of the continent. Cartooning sketches show idealized, rueful, or hilariously cock-eyed views of the West at that dynamic time in its history.

Modern writers occupy the rest of the Exhibition Hall. Visitors have a glimpse of some very large single-author collections, most acquired by the Huntington in recent decades. Representative pieces are on view from the private libraries of Jack London, Wallace Stevens, and Conrad Aiken; archives including letters and papers that detail their literary lives. Important books by other major figures – Joyce, Yeats, Eliot, Pound – illustrate the selective but rich vein of contemporary literature.

The material on view in the Exhibition Hall gives only an inkling of the Library's collections, about six million items safely stored in climate-controlled stacks. Just a sampling of particular areas reveals concentrations like these: the largest collection of American fiction on record; about ninety-five percent of all Renaissance English plays and masques in early editions; more than fifty separate manuscript collections concerned with the American Civil War; documents for study of British medieval history unequalled anywhere in the United States; one of the world's largest collections of books printed in England before 1641.

Beyond the visitors' Hall, behind the scenes, the 1500 readers who come to the Huntington each year to work in these collections have access to about 350,000 rare books, 5,000,000 manuscripts, 200,000 photographs of historic and artistic interest, about 5,000 printed and 4,000 manuscript maps, and supporting collections of pictorial prints and drawings, sheet music, and ephemera amounting to thousands of items. To aid research, the Library also offers an extensive reference collection and many specialized indexes and catalogs. Photographic reproductions of Huntington items are ordered by the hundreds each year and sent to scholars everywhere in the world. Results of Huntington research are widely disseminated, some through the Library's own publishing program of books for scholars and for general readers.

The Huntington continues to acquire books and manuscripts at a lively rate, through purchase and gifts. While holding to its original focus for the sake of depth and completeness, the Library occasionally ventures into new collecting fields. The history and philosophy of science, for example, is currently a very active area of growth. Recent collecting has brought hundreds of titles in such specialties as sixteenth and seventeenth-century English science, geology, electricity, American medicine, botanical works, and many landmarks in the history of chemistry. Altogether, the Library's holdings are now three times what they were at Mr Huntington's death in 1927, the manuscript materials more than doubled, reference works and modern literature entirely new, with great gains made in Western Americana and the prized early English books. Skill, persistence, and luck have built these remarkable collections through purchase, and many friends of the Library have generously added gifts-in-kind. Its holdings record the major achievements in Anglo-American civilization; its users interpret and extend those accomplishments toward the intellectual frontiers of today.

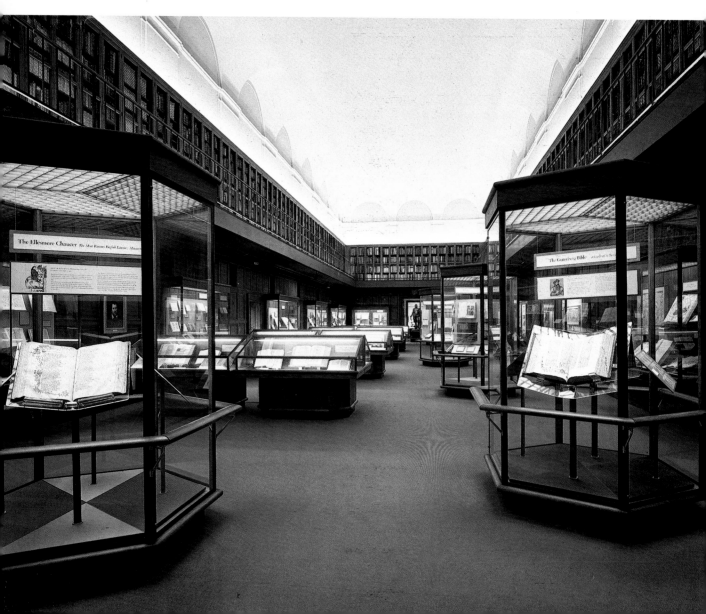

**Incunabula around the balcony of the Exhibition Hall**
This collection of about 10,000 volumes dates mainly from the fifteenth century, the first century of printing. Many of the books are in their original bindings.

**The Library Exhibition Hall**
In the cases of this impressive hall, two hundred of the Library's rarities are on display— only a fraction of the research collection numbering about six million items.

**The General Reading Room in the Library**
In this spacious room, lined with reference books, scholars pursue their research. Elsewhere in the Library is a Special Reading Room, where rare books and manuscripts can be consulted. Carrels and offices for scholars are scattered throughout an extensive system of bookstacks.

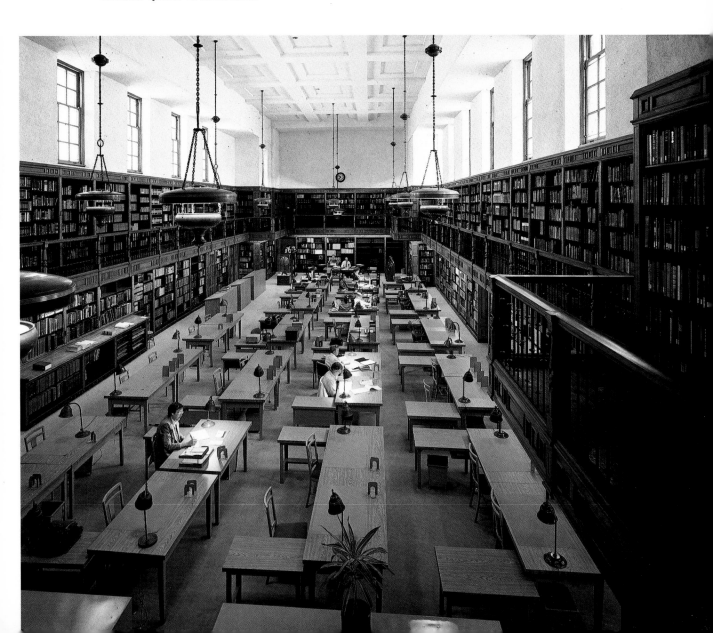

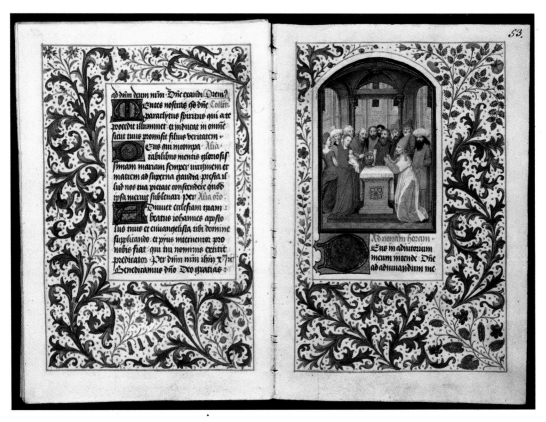

Manuscript Book of Hours, illuminated by Simon Marmion, Valenciennes, *c.* 1460-1465

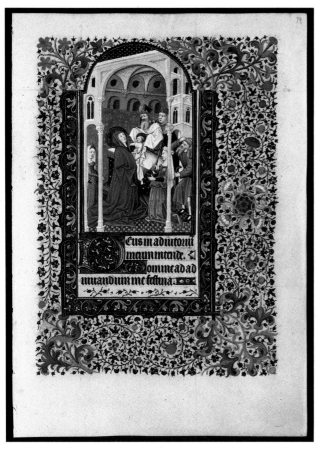

These two manuscripts are among the sixty-eight Books of Hours in the Library, the Marmion Hours having 124 leaves and that of the Bedford Master 210 leaves. Jewel-colored miniatures and rich borders enhance the liturgical texts. Both miniatures here illustrate the Presentation of the Infant Christ in the Temple, with a curious contrast: the Marmion picture follows an ideal of true perspective in the architectural setting, while the Bedford (about fifty years earlier) has several "viewpoints" and a free-floating treatment of space.

Manuscript Book of Hours, from the workshop of the Master of the Bedford Hours, Paris, *c.* 1420-1440

Giovanni Boccaccio, *De casibus (The Fall of Princes)*, translated by John Lydgate, English manuscript, *c*.1440. These very popular tragic tales were translated from Latin to English for this manuscript, which contains fifty-six miniatures.

Towneley Manuscript of Mystery Plays (Wakefield Cycle), *c*. 1490
This is the only manuscript in existence of these thirty-two short plays and, as such, it is a vital source for study of medieval drama. This manuscript was evidently the working copy used by a company producing the plays.

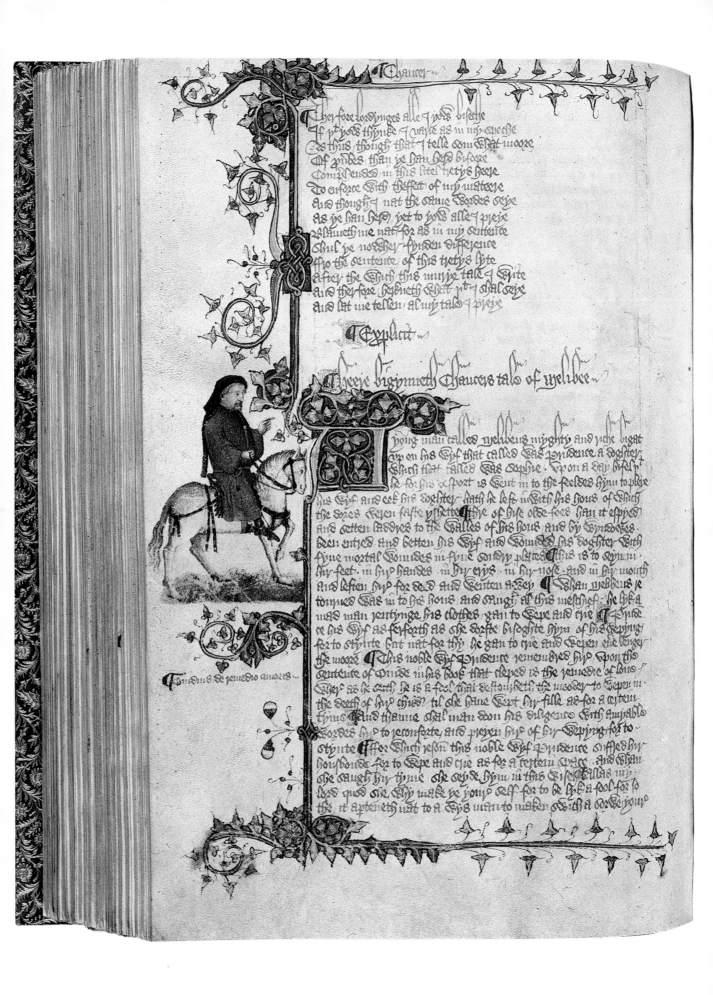

Ther fore lordynges alle I yow biseche
If þat yow thynke I varie as in my speche
As this thought that I telle som what moore
Of prouerbes than ye han herd bifoore
Comprehended in this litel tretys heere
To enforce with theffect of my mateere
And though I nat the same wordes seye
As ye han herd yet to yow alle I preye
Blameth me nat for as in my sentence
Shul ye nowher fynden difference
Fro the sentence of this tretys lyte
After the which this murye tale I write
And therfore herkneth what þat I shal seye
And lat me tellen al my tale I preye

¶ Explicit

Heere bigynneth Chaucers tale of Melibee

A yong man called Melibeus myghty and riche bigat
vp on his wyf that called was Prudence a doghter
which that called was Sophie vpon a day bifel þat
for his desport is went in to the feeldes hym to pleye
his wyf and eek his doghter hath he left inwith his hous of which
the dores weren faste yshette Thre of hise olde foes han it espyed
and setten laddres to the walles of his hous and by wyndowes
been entred and betten his wyf and wounded his doghter with
fyue mortal woundes in fyue sondry places This is to seyn in
hir feet in hir handes in hir erys in hir nose and in hir mouth
and leften hir for deed and wenten awey ¶ Whan Melibeus re-
torned was in to his hous and saugh al this meschief he lyk a
mad man rentynge his clothes gan to wepe and crie ¶ Pru-
dence his wyf as ferforth as she dorste bisoghte hym of his wepyng
for to stynte but nat for thy he gan to crie and wepen euere lenger
the moore ¶ This noble wyf Prudence remembred hir vpon the
sentence of Ouide in his book that cleped is the remedie of loue
wher as he seith he is a fool that destourbeth the mooder to wepen in
the deeth of hir child til she haue wept hir fille as for a certein
tyme And thanne shal man doon his diligence with amyable
wordes hir to reconforte and preyen hir of hir wepyng for to
stynte ¶ After which reson this noble wyf Prudence suffred hir
housbonde for to wepe and crie as for a certein space and whan
she saugh hir tyme she seyde hym in this wise Allas my
lord quod she why make ye youre self for to be lyk a fool for to
thus it aperteneth nat to a wys man to maken swich a sorwe youre

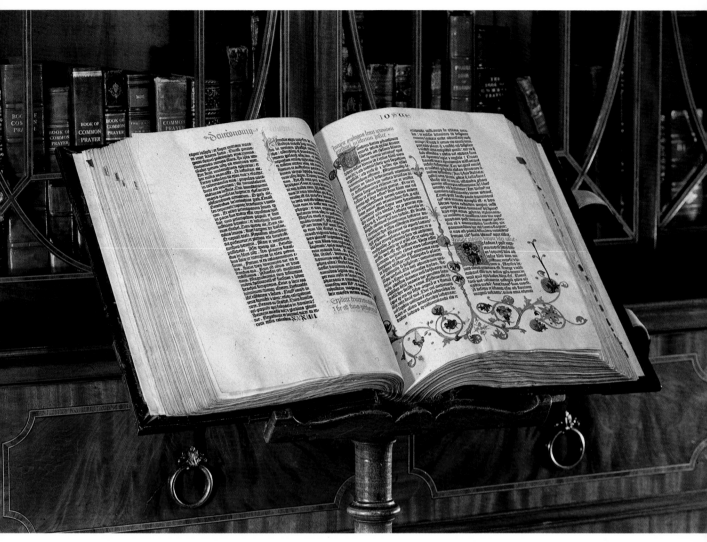

The Gutenberg Bible, Mainz, Germany, *c.* 1455. Two volumes
This beautiful landmark, produced by Johannes Gutenberg, is the first book printed with movable type in Europe. It contains both Old and New Testaments and the Apocrypha, in the Latin text known as the Vulgate. The Huntington copy is one of twelve copies printed on vellum; thirty-six copies on paper also survive. The large illuminated initial letters and flowing marginal decorations were added by hand after the printing. In their fifteenth-century calfskin bindings, these volumes create an impression worthy of their notable position in our history.

Geoffrey Chaucer, *The Canterbury Tales*, the Ellesmere manuscript, *c.* 1410
This cherished volume is the most elaborately decorated and beautiful manuscript of Chaucer's famous *Tales*. It contains the portrait of Chaucer shown here (believed to be the best likeness we have) and portraits of twenty-two of the fictional pilgrims who tell their stories. Long valued for the most complete text of this most important medieval work, the Ellesmere Chaucer uniquely combines the literary and the artistic imagination of its time.

St Augustine, *De civitate Dei,* Subiaco, 1467
This handsome volume came from the first press in Italy, established about 1464 in the
Benedictine monastery of Subiaco, near Rome. It is the first printed edition of
Augustine's powerfully influential work *The City of God.*

Pliny, *Historia naturalis,* printed on vellum by Nicolaus Jenson, Venice, 1472
Jenson, one of the great early printers, designed the elegant roman type of this book.
He was influenced in his design by the "littera antiqua", the handwriting favored
by Italian Renaissance humanists for copying ancient texts.

Raoul Le Fevre, *The Recuyell of the Histories of Troy,* translated and printed by William
Caxton, Bruges, Flanders, 1475.
In the frontispiece of this, the first book printed in the English language, a man (probably
Caxton) presents the book to his patroness, Margaret, Duchess of Burgundy. The
Huntington has the only known copy of this frontispiece.

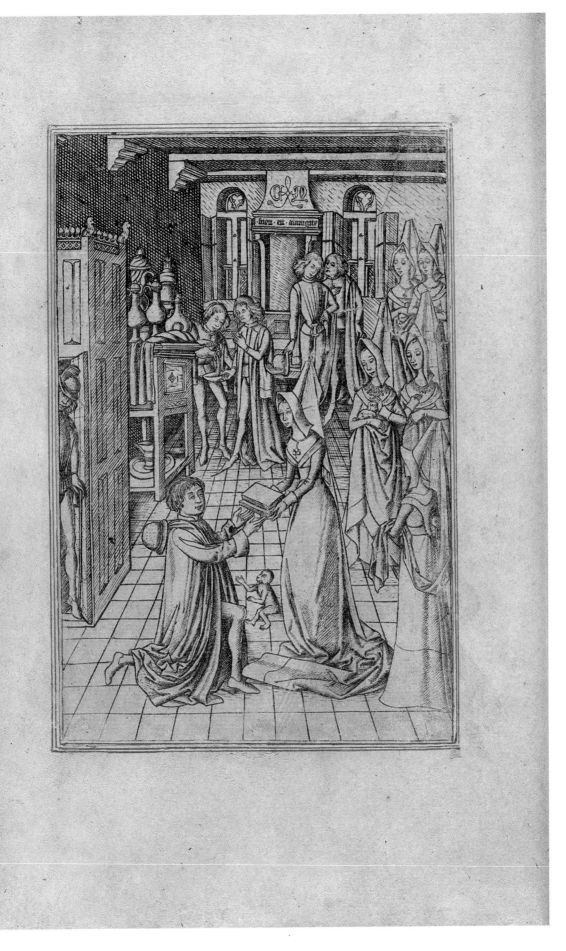

25

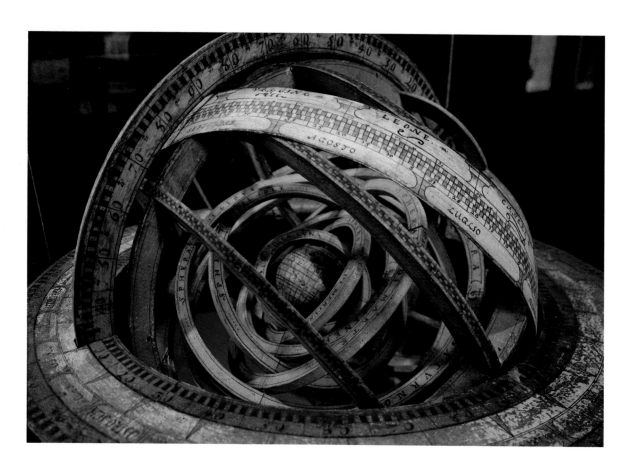

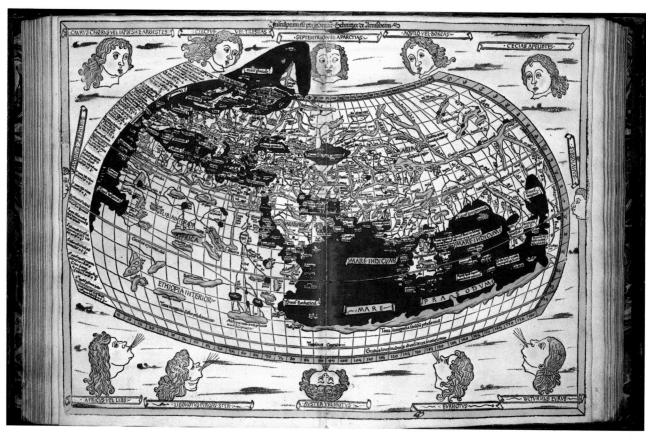

Antonio Santucci (attributed maker), *Armillary Sphere, c.* 1580
The earth is the center of Creation in this model based on the Ptolemaic conception
of the universe. Around the earth are the seven planetary spheres and the sphere of the
fixed stars.

Ptolemaeus, *Cosmographia*, Ulm, 1482
This standard geography of the ancient world was prepared about A.D. 510 and reprinted
dozens of times during the fifteenth and sixteenth centuries. The 1482 edition
contains thirty-two maps, including this view of the known world.

Nicolas Vallard, *Enssuyt Le Regime et gouvernement du Solliel* (Vallard manuscript atlas
of portolan charts), Dieppe, France, 1547
There are fifteen splendidly detailed charts in this book, the most famous manuscript
atlas at the Huntington. Designed to show sea-coasts and ports (hence "portolan"),
the maps show a lively fascination with geography – the figures, animals, and buildings
of distant lands, and the ships and "compass roses" essential to seafarers. Shown
here: Jacques Cartier's landing in Canada.

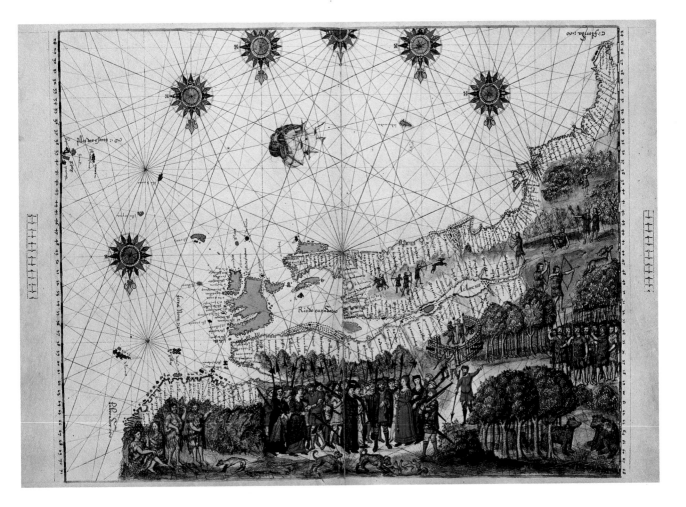

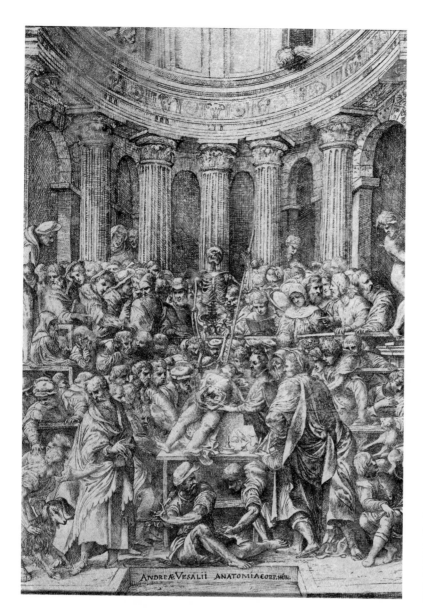

Andreas Vesalius, *De humani corporis fabrica,* Basle, 1543. First edition
This preliminary drawing, attributed to Domenico Campagnola, was prepared for the title page of Vesalius' great work on human anatomy. Classical architectural elements surround the scene, which is packed with life and a sense of wonder.

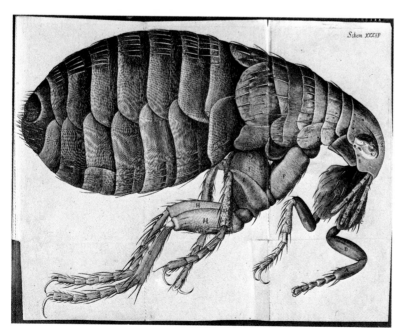

Robert Hooke, *Micrographia,* London, 1665. First edition.
A vital step in Renaissance science was Hooke's perfecting of the compound microscope. This book contains many plates illustrating his microscopic observations, including this flea, surely an astonishing sight in the seventeenth century.

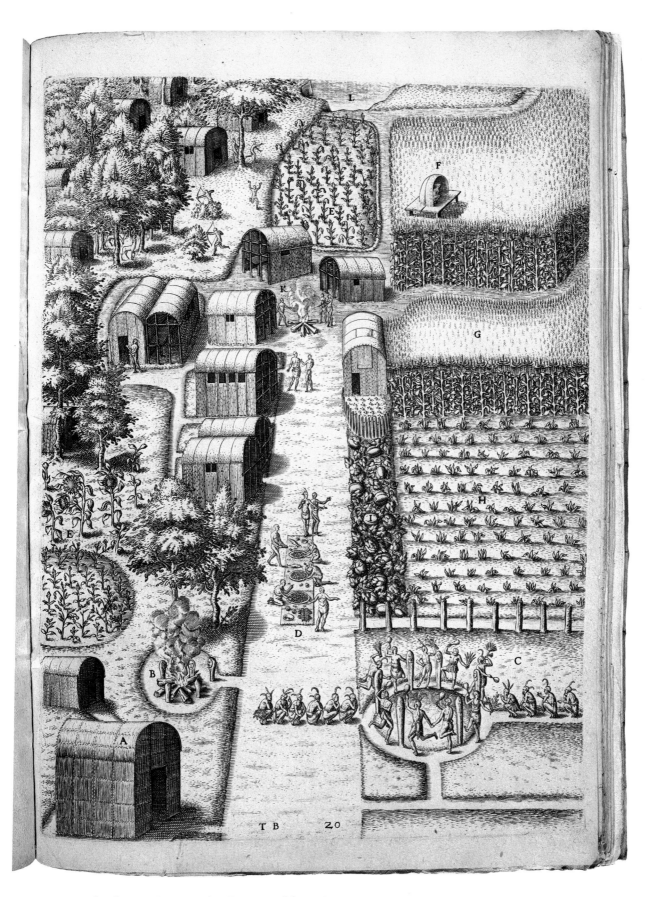

Theodore De Bry, *America*, Part I, Frankfurt, 1590
De Bry published a series of illustrated books about lands discovered in early explorations.
This drawing shows the Indian village of Secoton, in present-day North Carolina, with
Indians engaged in farming, hunting, and religious ceremonies.

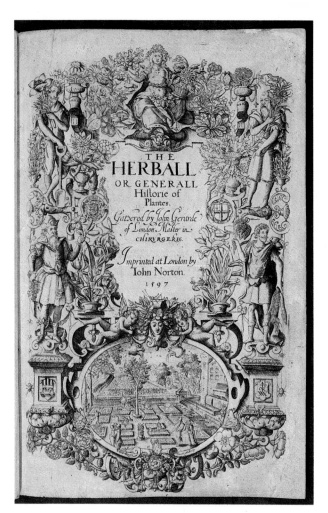

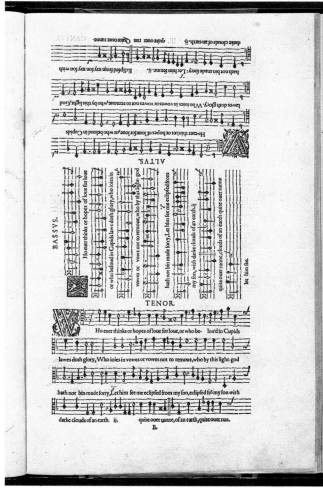

John Gerard, *The Herball or Generall Historie of Plants.* London, 1597. First edition
Valuable to painters and writers of the period, including Shakespeare, this was the most widely used botanical book in Elizabethan England. Many of its plants may be found in the Herb Garden and elsewhere at the Huntington.

John Dowland, *First Book of Songs or Ayres*, London, 1597
From the Huntington's fine collection of early English music comes this edition of airs, printed in a format which allows several singers and a lutenist sitting around a table to read from the same book.

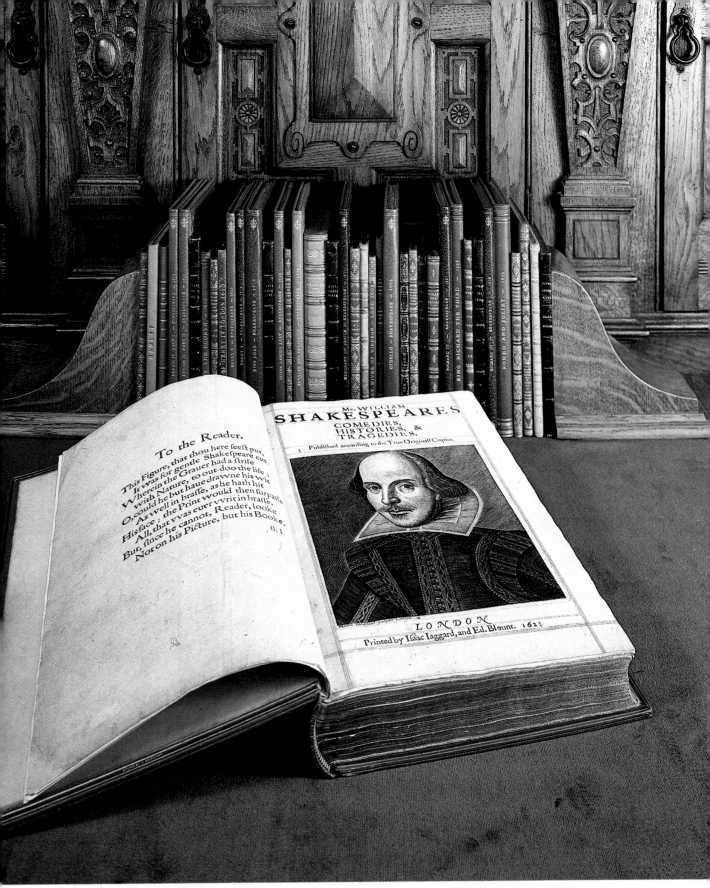

William Shakespeare, *Comedies, Histories, and Tragedies*, London, 1623 (the "First Folio"), and a selection of rare early quartos

The first edition of Shakespeare's collected plays contains thirty-six plays, twenty of them printed for the first time. On the title-page appears the familiar portrait engraving by Droeshout; opposite, a prefatory poem by Ben Jonson. The quartos contain a wealth of variations, essential matter for the study of Shakespeare's texts. The Huntington collection of early editions of Shakespeare is unsurpassed by any other library.

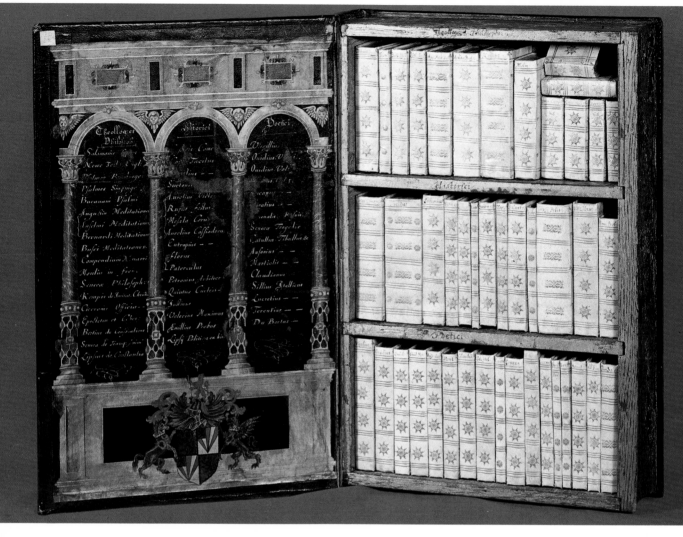

Travelling library of Sir Thomas Egerton, Lord Ellesmere, *c.*1615
The forty-four tiny volumes, bound in vellum, are stored in a gilded box which is itself
in the shape of a book. Their original owner was a prominent lawyer and judge
under Elizabeth and Lord High Chancellor under James I. The set is divided into Religion
and Philosophy, History and Poetry.

Map of the estate of Stowe, frontispiece of *Stowe: A Description of the House and Gardens.*
Buckingham, 1788
Eight hundred years of British history from the twelfth to the twentieth century) may
be traced in the extensive Stowe collection, papers of the Temple and Grenville
families in Buckinghamshire.

Literature of the English Renaissance
This classic collection of books from the sixteenth and seventeenth centuries includes
the greatest works by Sir Philip Sidney, Edmund Spenser, John Milton, and John Bunyan.
The manuscript contains poems by John Donne in a seventeenth-century anthology.

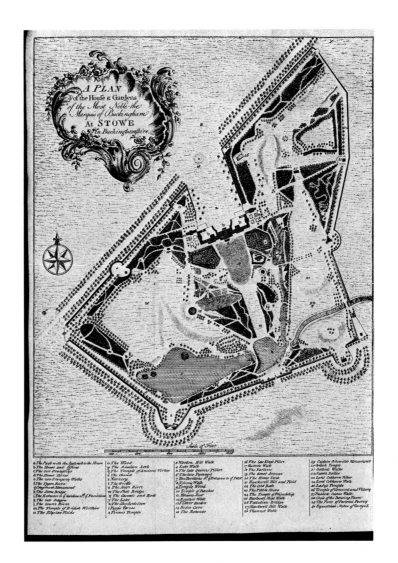

A PLAN of the House & Gardens of the Most Noble the Marquis of Buckingham At STOWE In Buckinghamshire.

Scale of Feet

a The Park with the Approach to the House
b The House and Offices
c The two Orangeries
d The House Terrass
e The two Orangery Walks
f The Upper River
g Congreve's Monument
h The Stone Bridge
i The Entrance to ye Gardens & ye Parterres
k The late Octagon
l The lower River
m The Temple of British Worthies
n The Elysian Fields

o The Wood
p The Grecian Ark
q The Temple of Ancient Virtue
r The Church
s Nursery
t The Grotto
u The Shire River
w The Shell Bridge
x The Cascade and Rock
y The Lake
z The Shepherds Cove
1 Dorics Terrass
2 Pyramid Temple

3 Warden Hill Walk
4 Lake Walk
5 The late Queens Pillar
6 The late Pyramid
7 Two Divisions of ye Entrance to ye Park
8 Nelsons Walk
9 Temple Wood
10 Temple of Bacchus
11 Pleasure Seat
12 Nelsons Walk
13 Lower Garden
14 Dido's Cave
15 The Rotundo

16 The late Kings Pillar
17 Queens Walk
18 The Parterre
19 The Great Avenue
20 The Home Park
21 Hawkwell Hill and Field
22 The Old Bath
23 The Pebble Alcove
24 The Temple of Friendship
25 Hawkwell Hill Walk
26 Palladian Bridge
27 Hawkwell Hill Walk
28 Thames Walk

29 Captain Grenville Monument
30 Gothic Temple
31 Artichoke Walk
32 Lamb's Beehive
33 Lord Cobham Pillar
34 Ladyship Temple
35 Temple of Concord and Victory
36 Paddock Copse Walk
37 Circle of the Dancing Fauns
38 The Plain of Portland Poetry
39 Equestrian Statue of George I

---

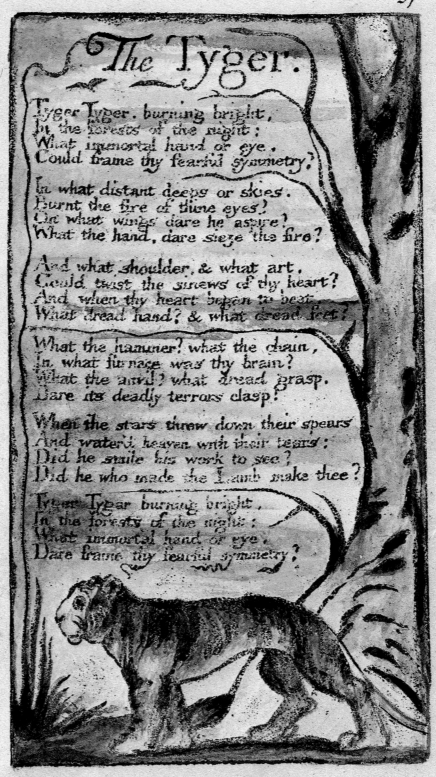

**William Blake,** *Songs of Innocence and of Experience,* **London, 1794**
The lovely picture-poems of this small book illustrate the complete integration of verbal
and visual art. The illuminated pages were entirely created by Blake, etched and then
handcolored by him; he was even his own publisher and bookseller. Other copies contain
variations on the subtle colorings shown here.

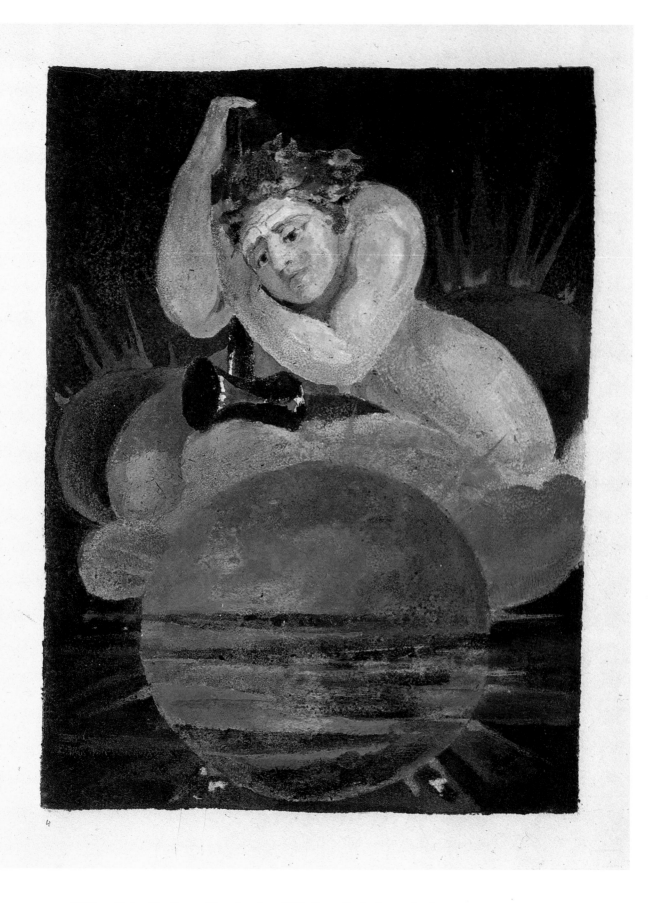

4

William Blake, *The Song of Los*, London, 1795. One of only five copies known .
This illustration for Blake's mythological poem is simple and vigorous in style. In the
poem, the power of creativity prevails over reason and law.

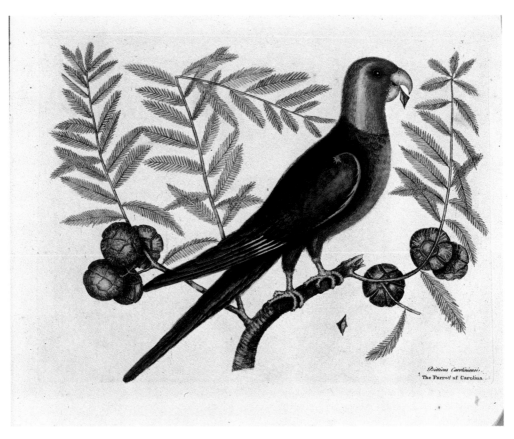

Mark Catesby, *The Natural History of Carolina, Florida and the Bahama Islands,* London, 1731–1743. Two volumes
This monumental work, the first American natural history, has more than 200 plates. The Parrot of Carolina, a surprising native in this land, shows the precision of Catesby's style.

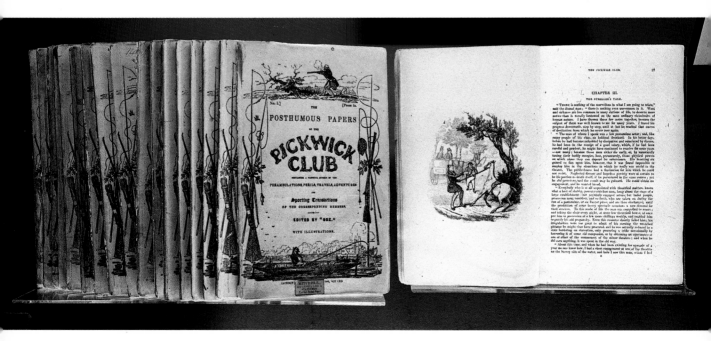

Charles Dickens, *Posthumous Papers of the Pickwick Club,* London, 1836–1837. Twenty monthly parts
Dickens' popularity grew with each instalment of this spirited novel: five hundred copies of the first number were printed, but by the fifteenth, forty thousand copies were needed. Many novels by the great Victorian writers were first issued in such inexpensive serial parts.

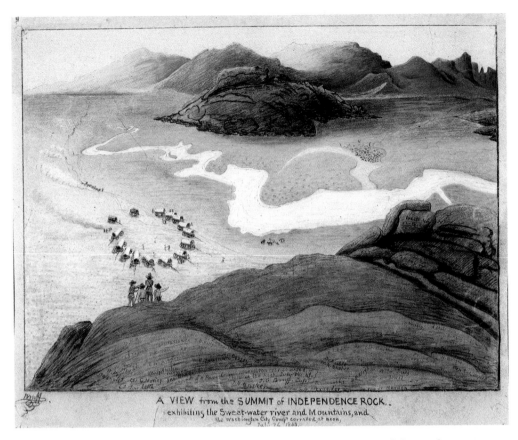

J. Goldsborough Bruff, *A View from the Summit of Independence Rock, Exhibiting the Sweet-water River and Mountains, and the Washington City Company Corralled at Noon, July 26, 1849,* pastel drawing.

Bruff joined a party of Forty-Niners seeking gold in California, and travelled the famed Oregon trail past Independence Rock. In this drawing from his richly illustrated journal, the names of travellers may be seen carved on the rock (some dimly visible even today), including "J.G. Bruff".

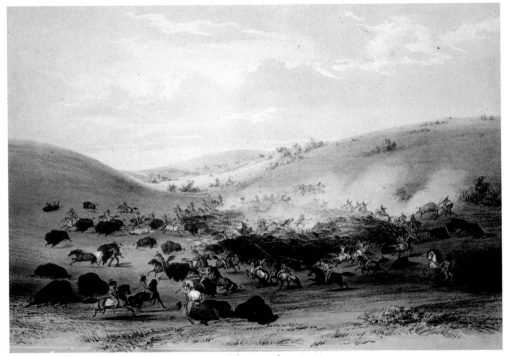

George Catlin, *North American Indian Portfolio,* London, 1844

Catlin dedicated his art to preserving "the vanishing races of native man in America", and he produced hundreds of paintings showing the Great Plains Indians and their way of life. His pictures have great variety, impressing us with their dramatic sweep, or drawing us closer with their fineness of detail.

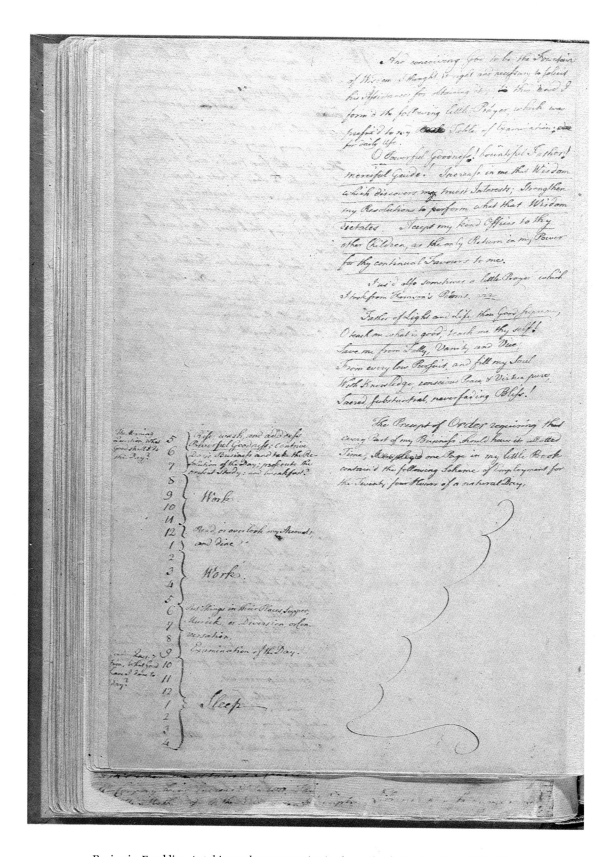

Benjamin Franklin, *Autobiography*, manuscript in the author's handwriting, 1771–90
Begun when Franklin was sixty-five, and continuing until his death at eighty-four, the
*Autobiography* records the thoughts of this talented man and his striving for
self-improvement. Its narrative is alive with charm and good sense. Practical suggestions
abound, and a many-faceted personality emerges. The page shown contains Franklin's
daily schedule, which includes rising at 5:00 with "The Morning Question: What Good
Shall I do this Day?" and a generous portion of "Work". Acquired by Mr Huntington in
1911, this manuscript has been one of the Library's treasures ever since.

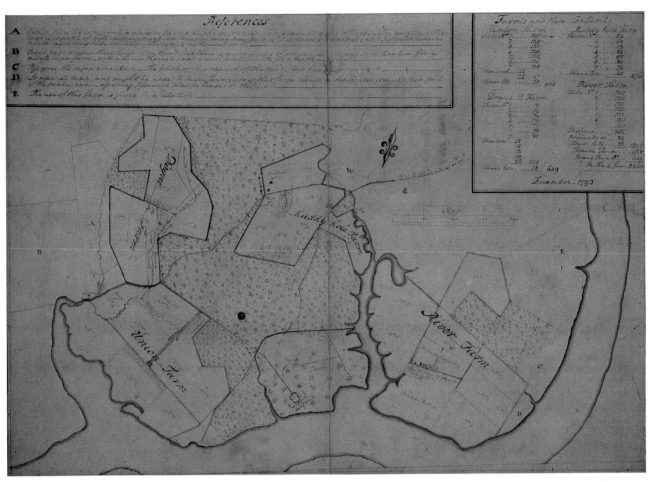

Autograph map of George Washington's Mount Vernon estate, 1793
Exhibited with letters and other documents relating to Washington, Franklin, and Jefferson, this map illustrates the Huntington's wide-ranging collections of these three Founding Fathers of the United States.

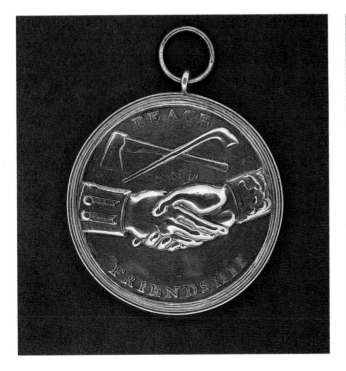

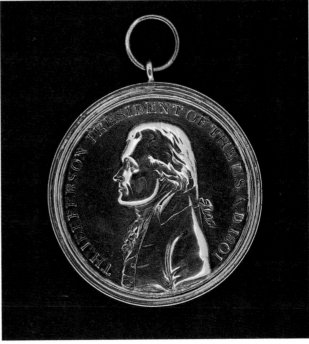

Thomas Jefferson Medal presented to an Indian tribe by the Lewis and Clark Expedition, *c.* 1804

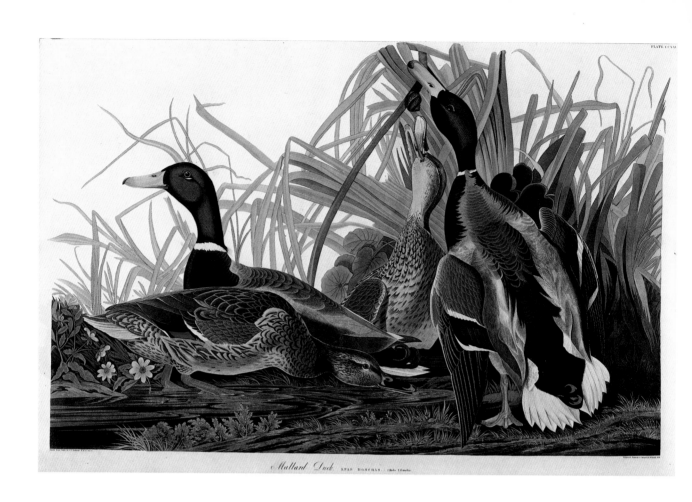

PLATE CCXXI

Mallard Duck. ANAS BOSCHAS. (Male. Female.)

John James Audubon, *The Birds of America*, London, 1827–1838. Four volumes,
double-elephant folio
435 plates, illustrating 1,065 birds, appear in these extraordinary volumes, the life's
work of Audubon. The very great size of the folios and the scientific accuracy
of the images make a powerful impression on all who see them. This plate, showing
Mallard Ducks, is one of the most intensely colored and artfully composed of all
these famous pictures.

40

Executive Mansion
Washington, April 30. 1864

Lieutenant General Grant.

Not expecting to see you again before the Spring campaign opens, I wish to express, in this way, my entire satisfaction with what you have done up to this time, so far as I understand it. The particulars of your plans I neither know, or seek to know. You are vigilant and self-reliant; and, pleased with this, I wish not to obtrude any constraints or restraints upon you. While I am very anxious that any great disaster, or the capture of our men in great numbers, shall be avoided, I know these points are less likely to escape your attention than they would be mine— If there is anything wanting which is within my power to give, do not fail to let me know it.

And now with a brave Army, and a just cause, may God sustain you.

Yours very truly
A. Lincoln.

Abraham Lincoln, Letter to Ulysses S. Grant, in the author's handwriting, April 30, 1864

Great American novelists of the nineteenth century
The Huntington's American fiction is well represented by this rich display: seen here
are manuscripts and first editions of works by Nathaniel Hawthorne, Henry James,
Herman Melville, and Samuel Clemens (Mark Twain).

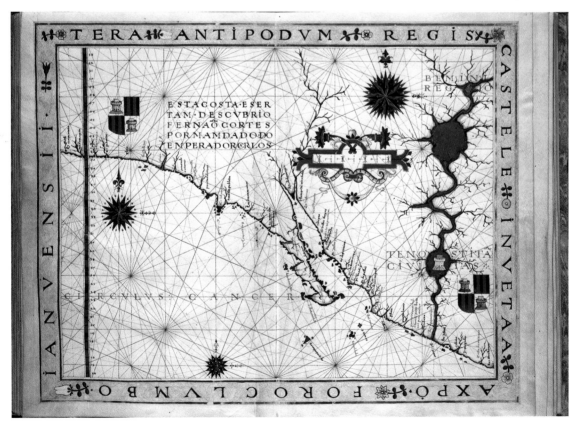

Fernaõ Vaz Dourado, *Esta costa e sertam descubrio Fernaõ Cortes por mamdado do
Emperador Carlos*, manuscript portolan map, from *Mapa Mundo, c.*1570
This handsome early Portuguese map shows the California coast, with Mexico City
(Tenostita Civitas) as a castle in the lower left.

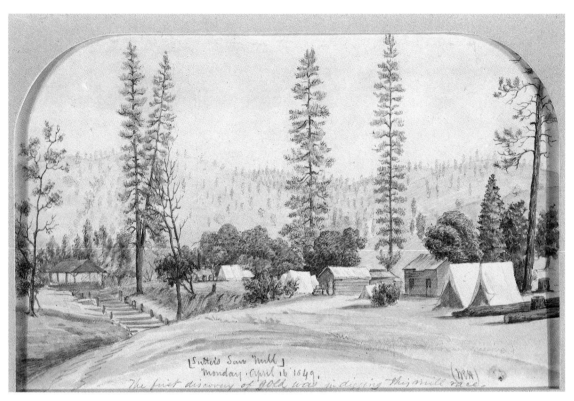

William Rich Hutton, *Sutter's Saw Mill*, watercolor, April 16, 1849
Hutton's historic drawing depicts a site near Sacramento, California, and has the penciled inscription "The first discovery of gold was in digging this mill race."

John Hovey, *Journal of a Voyage from Newburyport, Mass. to San Francisco, Cal. in the Brig Charlotte . . . Jan 23, 1849 . . . July 23, 1849*
Hovey kept this illustrated diary while voyaging to California's gold fields on the difficult six-month journey around Cape Horn. Here he sketches his ship, the Brig Charlotte, off the coast of Chile.

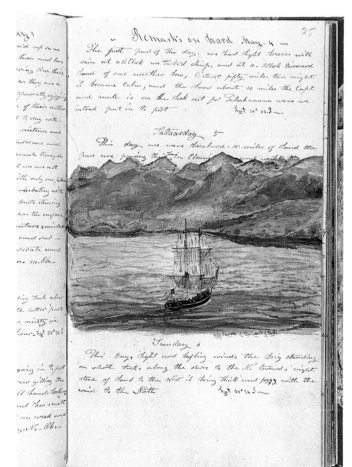

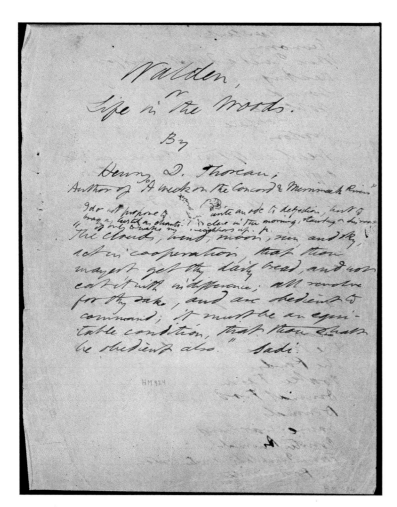

Henry David Thoreau, Manuscript of *Walden, or, Life in the Woods* in the author's handwriting

One of the most prized manuscripts in the Huntington is this record of Thoreau's experiences in a cabin he built at Walden Pond near Concord, Massachusetts in 1845. The book became a central document of the American experience, and its text and revisions have attracted much study. The Huntington has some four thousand pages of Thoreau manuscripts, many proof sheets, letters, and printed works.

The fiction of Jack London

The Huntington has London's own collection of his manuscripts, correspondence, scrapbooks, photographs, and first editions, as well as his personal library. The novels and tales shown here are known around the world.

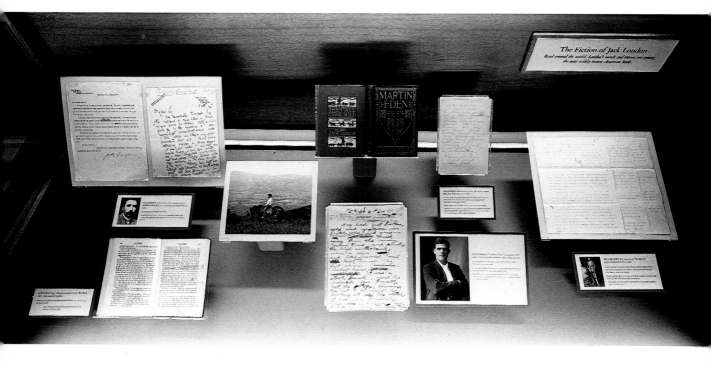

Wallace Stevens, Private journals in the author's hand, entry for July 29, 1906
The Huntington holds the extensive papers and private library of Stevens, who was one of the great American poets of this century. This journal page records a solitary walk from New York city into New Jersey and contains details which may have suggested themes found in his later poems.

Wallace Stevens *(right)* with Robert Frost
Photographs and letters at the Huntington document the friendships and working relationships of many contemporary writers.

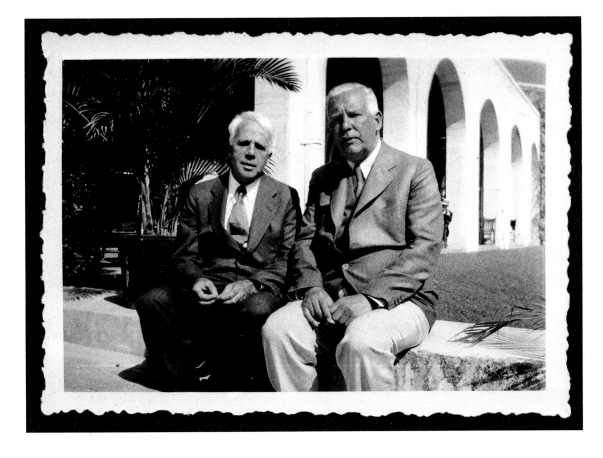

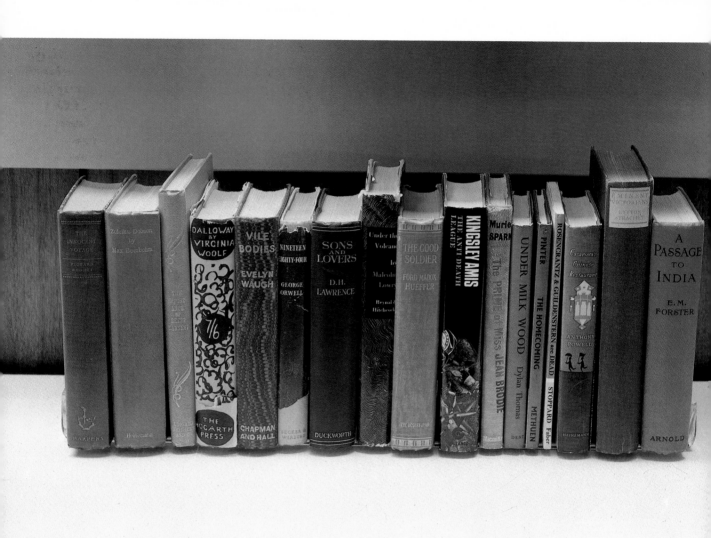

First editions of twentieth-century British authors
Representative of the research collection is this selection, including works by Virginia
Woolf, D.H. Lawrence, E.M. Forster, Dylan Thomas, and their contemporaries.

# THE ART GALLERY

 The Huntington Art Gallery offers a fascinating interplay of the elegant and the domestic. The collection is one of the most distinguished in America within its area of specialization – British and French art of the eighteenth century – and the variety of its holdings brings this period vividly to life. In the historical period represented, bounded by the dates of the American and the French revolutions, the art of England and France was the accepted standard of the day, and the eighteenth-century-style interiors of the former Huntington residence provide a worthy setting, evoking the surroundings in which the works of art were originally seen.

The majestic Sarah Siddons, painted by Reynolds as the Tragic Muse, is the focal point for the most grand effect of all: the Main Gallery with its constellation of splendid portraits. This group of twenty pictures, including major work by Gainsborough, Romney, Lawrence and Raeburn, is perhaps the finest gathering of full-length British portraits to be found anywhere. Amongst the paintings, dating from about 1770 to 1800, are two of the most famous and beloved images at the Huntington, *Pinkie* and *The Blue Boy*. In this gallery the grand gesture and rhetoric of exhibition portraiture mingle with the domestic, the personal. Mrs Siddons is regal, her pose and massiveness reminiscent of Michelangelo's sibyls. But near her, Karl Friedrich Abel (chamber musician to Queen Charlotte) sits quietly at his work of composing, surprised by his friend Gainsborough; his viol rests on his knee, ready to run through the next passage; at his feet his very appealing dog is watchful, resting but with eyes open. The room is worth an afternoon of study and reflection, observing these contrasts and appreciating the virtuosity of the painters.

Landscape is another area of British painting handsomely represented in the collections, with works including Constable's *View on the Stour near Dedham* and Turner's *Grand Canal Venice: Shylock*. Also on view are the small-scale group portraits called "conversation pieces" by Hayman, Devis, and Wheatley, genre pictures with animals by Stubbs, Marshall and Morland, and more than a hundred portrait miniatures from the seventeenth to the early nineteenth centuries, those delightful keepsakes painted on vellum or ivory to be exchanged among friends. All the major practitioners are included, from Hilliard and Oliver to Cosway and Smart.

More than twelve thousand British drawings and watercolors, the work of about five hundred artists, enrich the Huntington holdings still further: Blake, Rowlandson, Gainsborough, Turner and Constable are well represented. Selections are always on view in changing exhibitions, drawn from one of the most impressive collections of British draftsmanship to be found outside of London. Landscape, portrait, and narrative subjects (especially comic drawings) are included in these simple, lively, and fresh small pictures.

A limited but representative collection of British sculpture has recently been assembled and displayed, comprising mainly portrait busts, and a further addition of the last few decades has been several hundred pieces of British silver, covering the wide span from the late fifteenth to mid-nineteenth centuries. These appealing objects combine usefulness – in, say, a marrow spoon or a cream jug – with the rich luster and workmanship of elegant old silver. Surrounding and enhancing these throughout the building are British period furniture and other decorative arts. From the fine gilt-wood tables by Robert Adam to the Chelsea porcelain and Wedgwood ware, including the eighteenth-century pine paneling encompassing the Quinn Room, these pieces round out the comprehensive view of Georgian art to be enjoyed at the Huntington.

Continental European art provides a rich counterpart for these arts of England. In the Arabella Huntington Memorial, a special collection displayed in the Library building, are a number of Italian Renaissance paintings by minor masters, and a

few works by Flemish artists including an outstanding *Madonna and Child* by Roger van der Weyden. The Memorial also comprises ornamental Sèvres porcelain, French furniture with its highly elaborate surfaces of marquetry or gilt bronze, and an outstanding collection of French eighteenth-century sculpture. Other French decorative arts are found in the main Art Gallery, including more handsome furniture, ranging from the rococo style to the more restrained neo-classic. Clocks, candelabra, and other objects there once formed a background for aristocratic living in the half-century before the revolution. Grandest in scale are the ten Beauvais tapestries woven from designs by Boucher, and in complete contrast are some tiny personal possessions, a collection of snuffboxes made of gold, enamel and gems.

Perhaps most highly prized of the Continental pieces are the Renaissance bronze statuettes, a small collection but of remarkable quality, among which the works by Giovanni Bologna and his followers are particularly noteworthy. These delightful little objects from sixteenth-century Italy were made for private enjoyment in the study of an admirer. Here they invite the Huntington visitor to linger for a closer look, to marvel at their fineness and rich patina.

In 1978, the Huntington received a major bequest which has become the Adele S. Browning Memorial. The gift consisted of French, British, Italian, Dutch and Flemish paintings, along with decorative objects, all centering on the period of the French *ancien régime*. This acquisition brought the Huntington its first French paintings, and otherwise complemented in many ways the materials already here. Among the artists represented are Watteau, Boucher, and Fragonard, Romney, Hoppner, Canaletto, Rembrandt, and Van Dyck. The paintings are shown as a unit in four adjoining galleries, and they form a delightful excursion into Continental seventeenth and eighteenth-century art.

An even more recent gift, also of enormous importance, is the Virginia Steele Scott collection. The collection consists of fifty American paintings, carefully chosen by professionals in the field to represent the best of American art from about 1730 to 1930. Most of America's "old masters" are included: Copley, West, and Stuart for the early period; Sully, Bingham, Allston and many others for the nineteenth century; brilliant examples by Sargent and Cassatt from the end of the nineteenth century and, from the early twentieth century, fine characteristic works by artists such as Bellows, Hopper, Wood and Kuhn. These pictures will be housed in a separate gallery building, which will include archival resources for the study of American art. With this magnificent addition, the capacities of the Library and the Art Gallery become even more closely linked, as the former has since its inception centered on Anglo-American civilization.

Beyond the walls of the galleries, a wide variety of sculpture and architectural ornaments are to be found in the gardens. Little temples, statues, urns, benches, and especially the fountains – all lend a particular grace to the landscape setting. Notable examples are the thirty-one stone figures of the seventeenth century, brought from a villa garden near Padua, and now flanking the broad North Vista lawn; the Italian baroque fountain at the end of that vista; four bronze statues after classical originals, now beside the entrances of the Library building.

The holdings of the Huntington Art Gallery are continually growing, both through gifts and through purchase. The essential character of the collection, however, remains the same, allowing for a depth and internal harmony unmatched in most museums. But new treasures are constantly being added, pieces closely related in period or style to the original focus. The most up-to-date conservation work is carried out on pieces in need of attention. The regulations governing the Huntington forbid lending works of art, so the treasures can be seen at first hand only by visitors to the gallery; however, high quality reproductions are available for

the continued study and pleasure of the thousands who come each year. The collection is made more accessible for the public by an active program of talks, tours, and publications, and the scope is further widened by performances of music, dance, and drama related to the collection which add lively reflections in these sister arts.

The Huntington Art Gallery offers to the public a sense of history, a host of beautful things to see, and the intellectual pleasures of contrasts and surprises. But the most abiding recollection taken away by visitors may be the memory of a face: Houdon's gentle Sabine, with her hint of an archaic smile; spirited Pinkie, touching us with her simple, direct gaze; Van Dyck's proud lady; or the memorable Abel, harmonies crowding into his head while his friend, out of sight, works away at his canvas.

The Loggia at the entrance to the Art Gallery provides an elegant transition from the gardens to the art collection. French and German garden sculptures – terra-cotta, marble, and bronze – line the perimeter of the Loggia, backed by the foliage of the gardens.

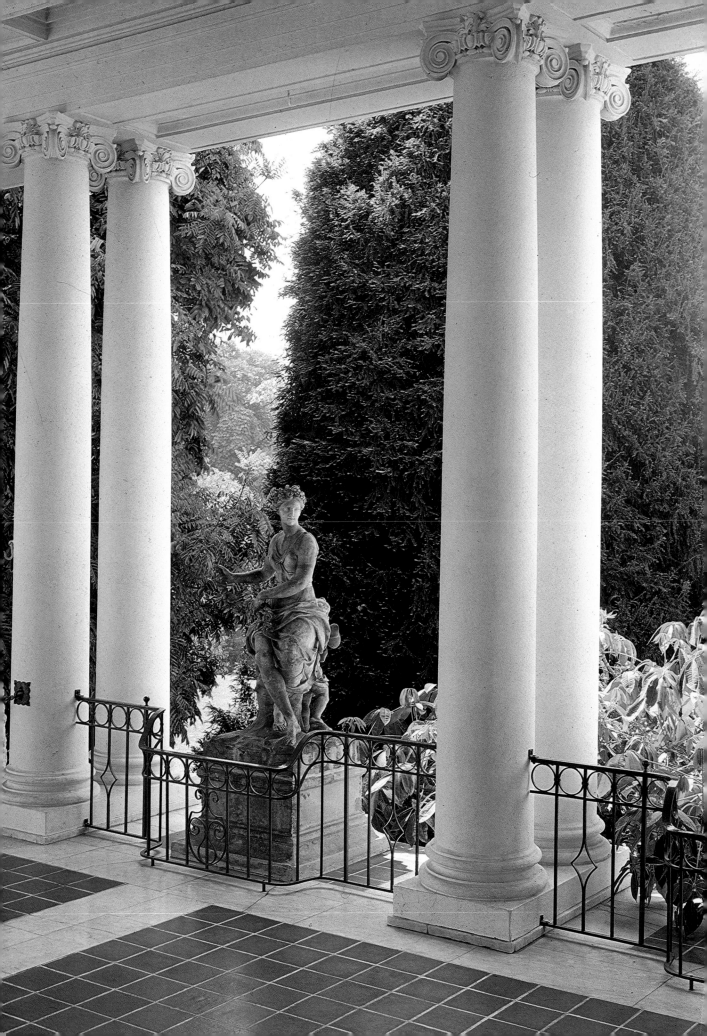

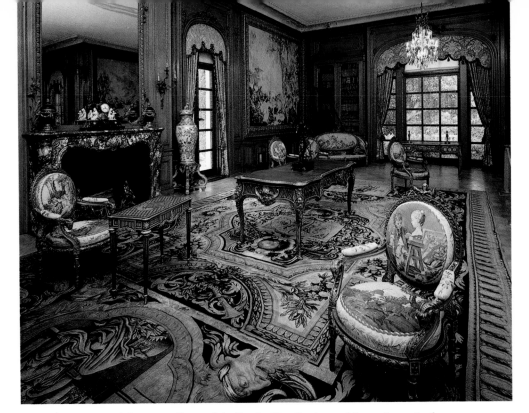

The **Dining Room** of the Art Gallery, originally the Huntington residence, is an Anglo-American room. One of Gilbert Stuart's many portraits of George Washington dominates the over-mantel. On the mantel shelf, just below, sits a marble bust of Washington's arch-adversary, George III. The late-eighteenth-century English chandelier sparkles over a mid-century English table set with eighteenth and early-nineteenth-century British silver.

The **Main Gallery** contains what is probably the finest assemblage of British full-length portraits existing anywhere in one room. Gainsborough, Reynolds, Romney, Lawrence are all well represented. Most of the portraits date between 1770 and 1795, and most appeared initially in the annual exhibitions at the Royal Academy. This circumstance may help to explain the stately air adopted by the painters.

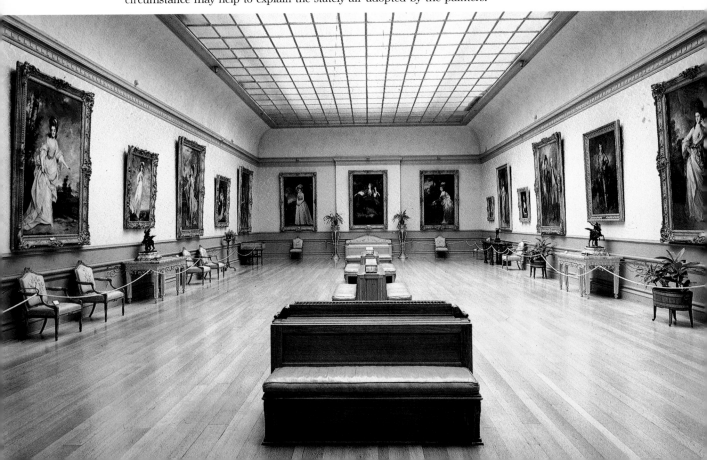

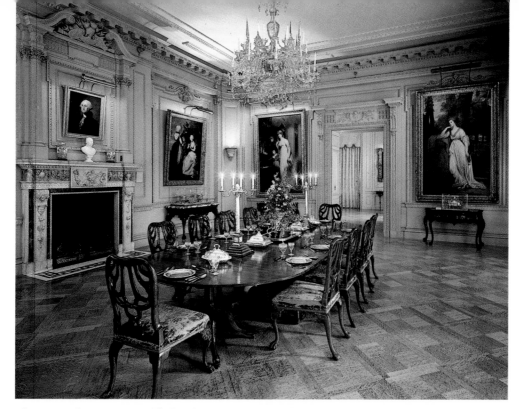

The **Large Library Room** is filled with important examples of French decorative art. The seventeenth-century Savonnerie carpets once graced the Grande Galerie of the Louvre; the mid-eighteenth-century Beauvais wall tapestries were also a royal commission; the Gobelins chair tapestries were almost certainly made for Mme de Pompadour. The desks and tables are likewise outstanding examples of French eighteenth-century craftsmanship.

The **panelling** in this room was assembled from three mid-eighteenth-century English houses: the walls from Castle Hill, Devonshire; the mantelpiece from Grove House, Chiswick; the double door and over-mantel from a house in Arlington Street, St James's. The panelling and the English furniture in the room were donated by Florence M. Quinn of Los Angeles. The room was opened to the public in 1944.

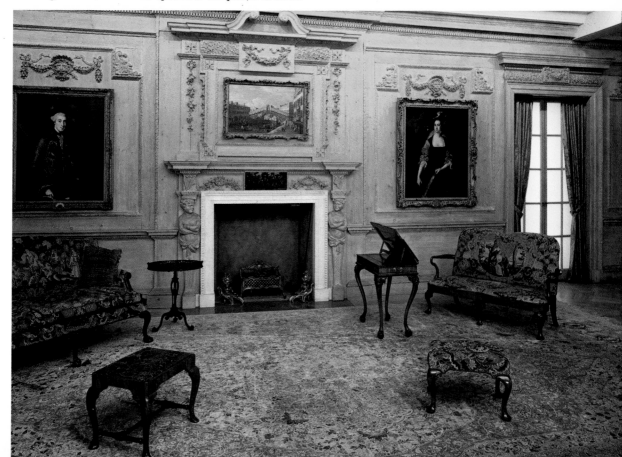

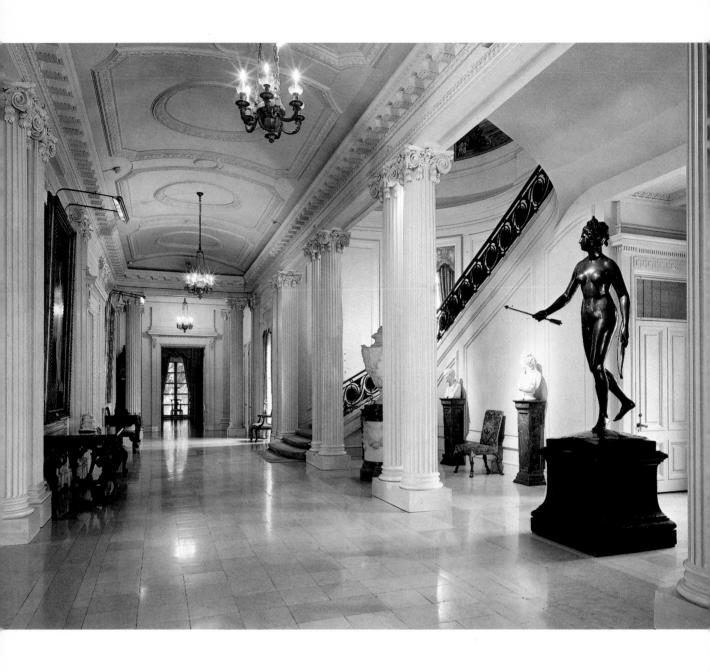

The Main Hall of the Art Gallery, featuring Jean-Antoine Houdon (1741-1828), *Diana*, 1782, bronze, H. 82in (209cm). Houdon's *Diana* is one of his most famous creations. He worked on it off and on through much of his life, and produced versions in plaster, marble, lead, and terra-cotta, as well as bronze. The Huntington version is the earliest of the bronze casts, and was made in 1782 for the Paris merchant, Girardot de Marigny.

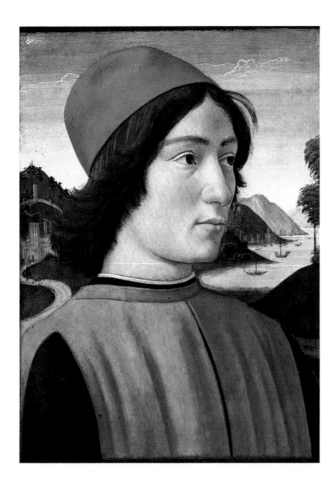

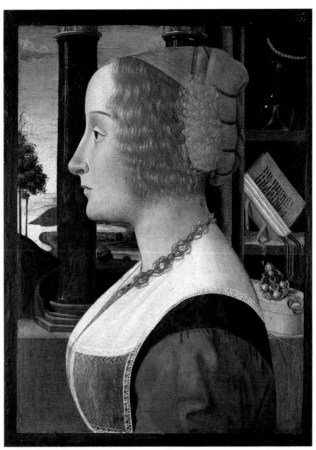

Sebastiano Mainardi (active 1493–1513), attr.
*Portrait of a Young Man*, oil on panel,
17 x 13in (43.2 x 33cm).

Sebastiano Mainardi (active 1493–1513), attr.
*Portrait of a Young Woman*, oil on
panel, 18 x 13in (45.7 x 33cm).

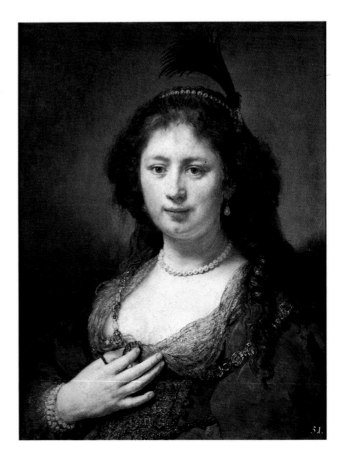

Rembrandt Hermanszoon van Rijn (1606–
1669), *Lady with a Plume*, 1636, oil on
panel, 25½ x 20in (64.8 x 50.8cm).

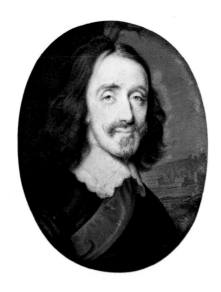

**John Hoskins** (*c*.1595–1665), *Charles I,*
*c*.1640–45, watercolor on vellum, 3⅛ x 2¾in
(7.9 x 7.0cm), oval.
This haunting miniature of the ill-fated king
was painted during the Civil War.

Sir Godfrey Kneller (1646–1723), *Sir William*
*Robinson*, 1693, oil on canvas, 50 x 40½in
(127 x 102.9cm).

Samuel Cooper (1609–1672), *Portrait of a man*, 1646, watercolor on vellum, 2⅛ x 1½in (5.4 x 4.0cm), oval.

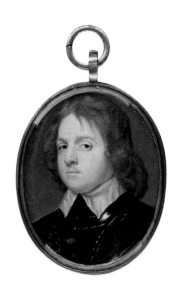

William Hogarth (1697–1764), *Benjamin Hoadly, Bishop of Winchester*, *c̄*.1740, oil on canvas, 24 x 19in (61 x 48.3cm). Hoadly, Bishop of Winchester, is represented in the robes of Prelate of the Order of the Garter. Windsor Castle, the seat of the Order, is in the background. Although the portrait is physically small, Hogarth aims for a grand effect through pose, costume, and stately accessories.

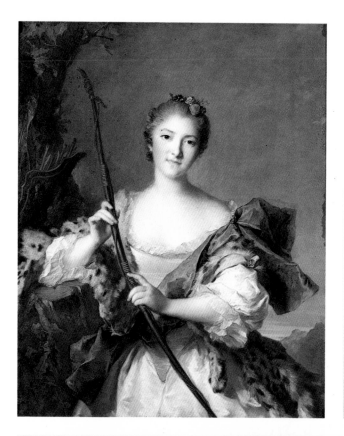

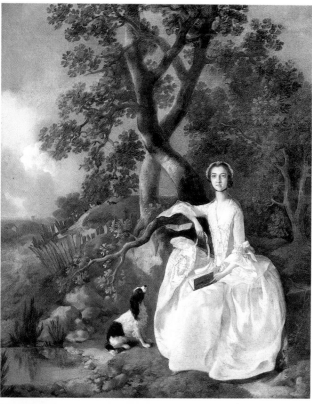

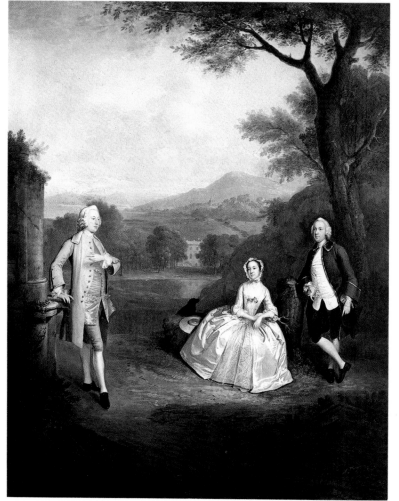

Jean-Marc Nattier (1685–1766), *Portrait of a Lady as Diana*, 1742, oil on canvas, 39 x 31½in (99.1 x 80cm).

Thomas Gainsborough R.A. (1727–1788), *Lady with a Spaniel*, c.1750, oil on canvas, 30 x 25in (76.2 x 63.5cm).
This early work by Gainsborough – physically small, prim, but charming – is in a manner he abandoned when he moved from Ipswich to the more fashionable centers of Bath and London.

Arthur Devis (1711–1787), *George, 1st Lord Lyttelton, His Brother Lt. Gen. Sir Richard Lyttelton, and Sir Richard's Wife Rachel*, 1748, oil on canvas, 49½ x 39½in (125.7 x 100.3cm).
Devis is a leading master of the "Conversation Piece", a type of small-scale, informal, group portrait that enjoyed wide popularity in eighteenth-century England. The "Conversation Piece" is an interesting contrast to the much more stately, life-size, full-length English portraits which are so well represented in the Huntington collection.

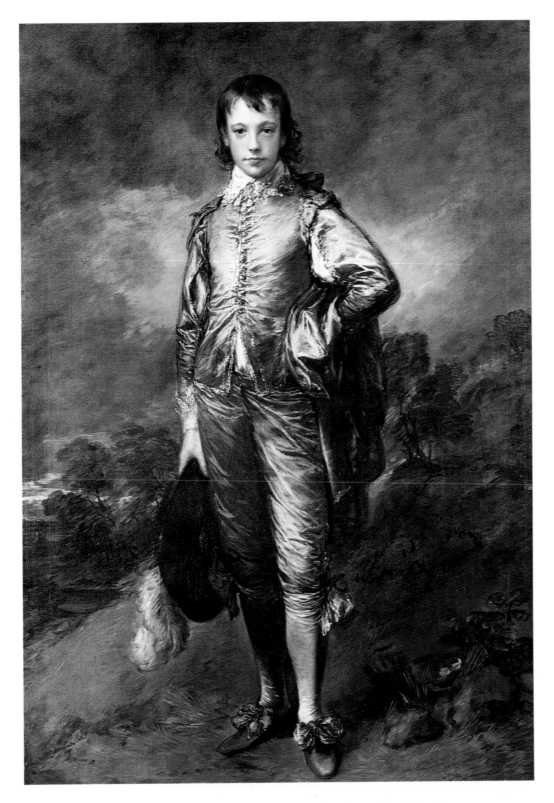

**Thomas Gainsborough** R.A. (1727–1788). *Jonathan Buttall: "The Blue Boy"*, *c*.1770, oil on canvas, 70 x 48in (178 x 122cm).

*The Blue Boy*, perhaps the most famous of all British portraits, poses many questions. We have no certain information about the painting until after Gainsborough's death. The available evidence indicates that the boy is Jonathan Buttall, son of a prosperous hardware merchant and a friend of Gainsborough. The picture is modelled – in costume, pose, and even paint handling – on the work of the earlier artist, Van Dyck, a painter Gainsborough admired above all others. These circumstances, together with the fact that Gainsborough painted the picture over an unfinished, cut-down portrait, suggest that *The Blue Boy* was not a normal commission, but something the artist painted for his own pleasure.

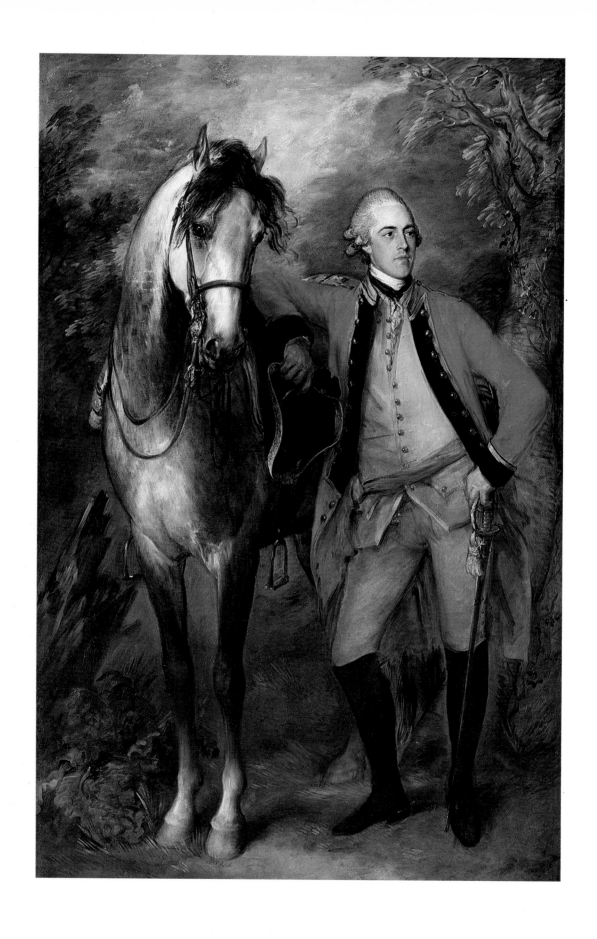

Thomas Gainsborough R.A. (1727–1788), *Edward, 2nd Viscount Ligonier*, 1770, oil on canvas, 92½ x 61½in (235 x 156.2cm).

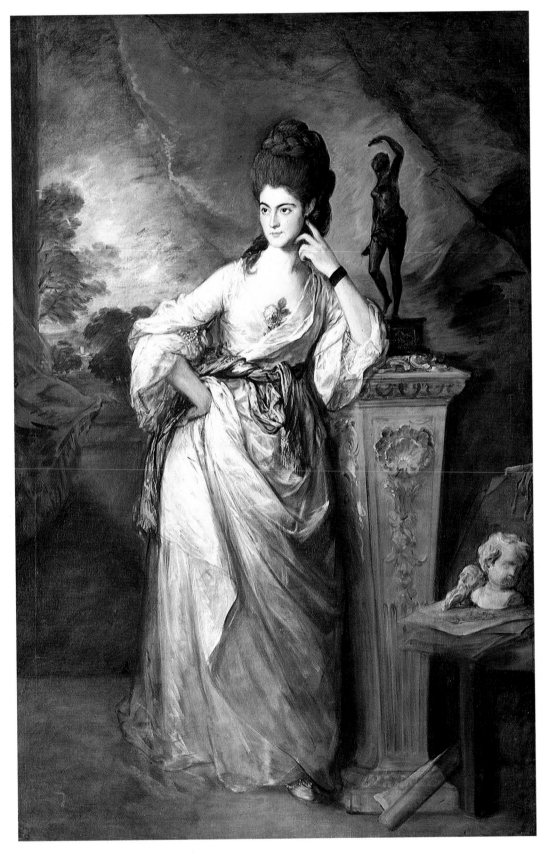

Thomas Gainsborough R.A. (1727–1788), *Penelope, Viscountess Ligonier*, 1770, oil on canvas, 93 x 61in (236.2 x 154.9cm).

At the time this portrait was painted, Lady Ligonier was about to become the principal figure in a sensational divorce scandal that rocked not only British but European society. The third point of the triangle was the Italian dramatist, Count Vittorio Alfieri, whose memoirs give a very full and spirited account of the affair.

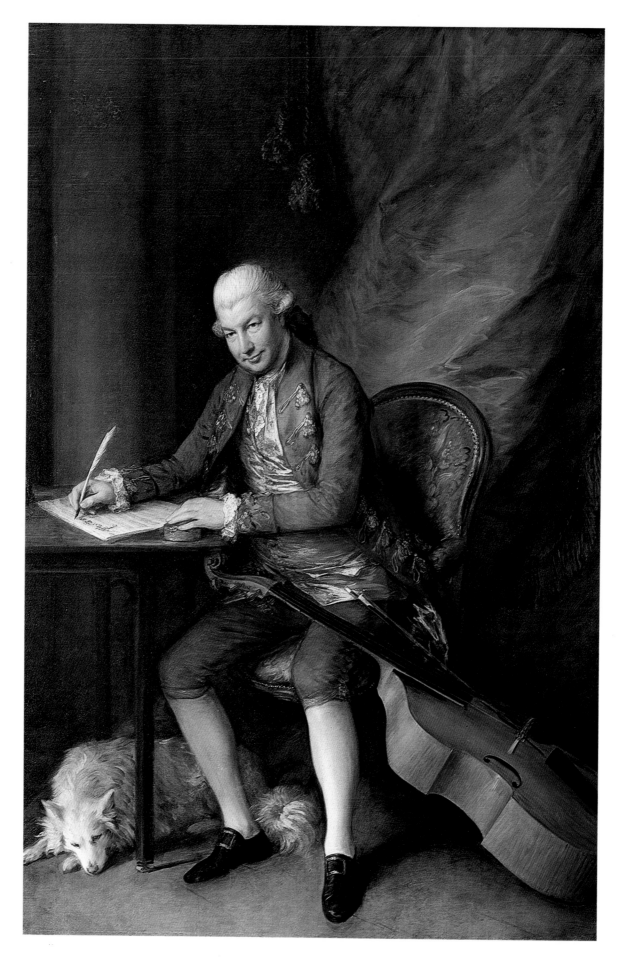

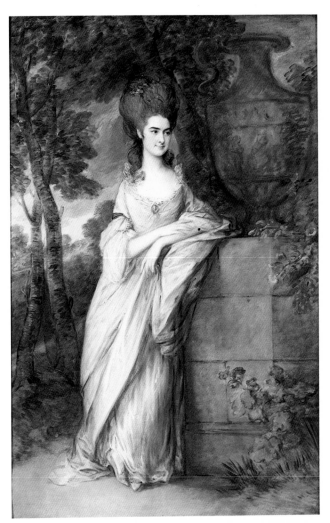 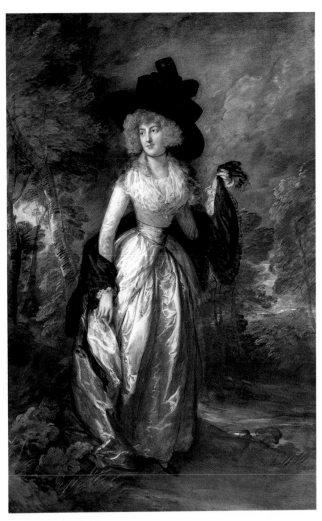

Thomas Gainsborough R.A. (1727–1788), *Mrs John Meares*, c.1777, oil on canvas, 88 x 55½in (223.5 x 141cm).

Thomas Gainsborough R.A. (1727–1788), *Juliana, Lady Petre*, 1788, oil on canvas, 88¾ x 57¼in (225.4 x 145.4cm).
The portrait was painted in the year of Gainsborough's death. In economy of brushwork – making a few squiggles into a convincing suggestion of a skirt or a tree – the painting shows Gainsborough's art at its fullest development.

Thomas Gainsborough R.A. (1727–1788), *Karl Friedrich Abel*, c.1777, oil on canvas, 88 x 58in (223.5 x 147.3cm).
Karl Friedrich Abel (1725–1787) was a distinguished musician, particularly noted as a composer for and performer on the viola da gamba, the instrument with which he is here portrayed. Abel was a close personal friend of Gainsborough, who was a passionate amateur musician.

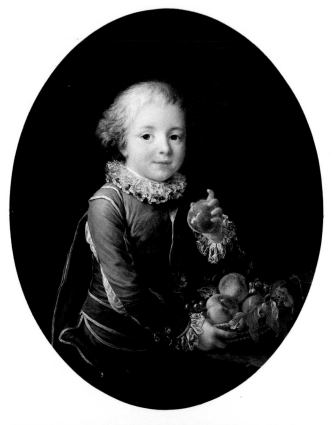

François-Hubert Drouais (1727–1775), *Boy with Peaches*, 1760, oil on canvas, 28 x 22in (71.1 x 55.9cm).

Allan Ramsay (1713–1784), *Anne, Countess Winterton*, 1762, oil on canvas, 30 x 25in (76.2 x 63.5cm).

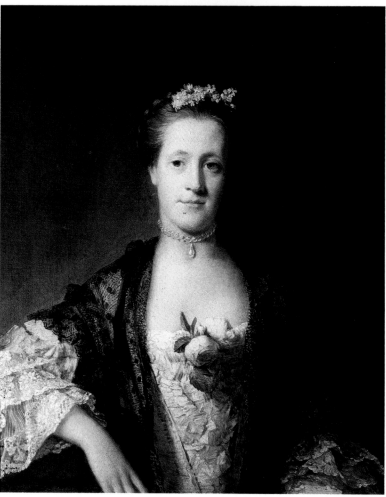

Sir Joshua Reynolds P.R.A. (1723–1792), ▷ *Georgiana, Duchess of Devonshire*, 1775–76, oil on canvas, 93¼ x 57in (236.9 x 144.8cm).

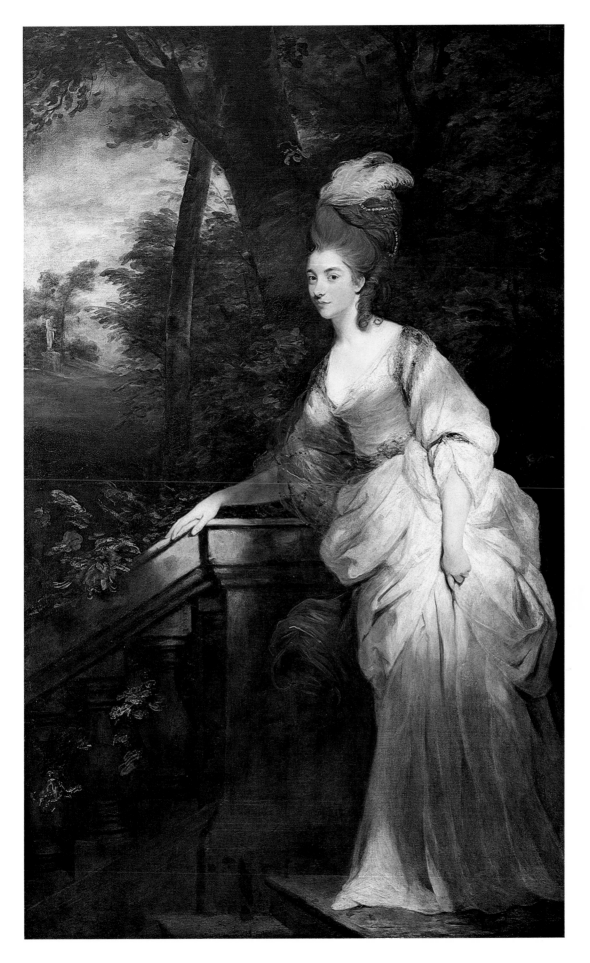

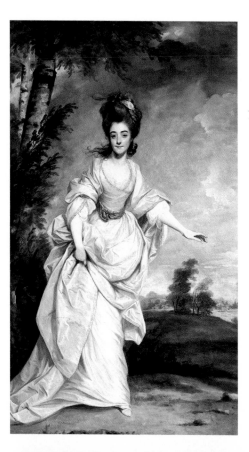

Sir Joshua Reynolds P.R.A. (1723–1792), *Diana, Viscountess Crosbie*, 1777, oil on canvas, 93 x 57in (236.2 x 144.8cm).

Sir Joshua Reynolds P.R.A. (1723–1792), *The Young Fortune Teller*, 1775, oil on canvas, 55 x 43in (139.7 x 109.2cm).
In this double portrait of two children of the fourth Duke of Marlborough, Reynolds makes a whimsical allusion, in costume and pose, to Caravaggio's *The Fortune Teller*, now in the Louvre.

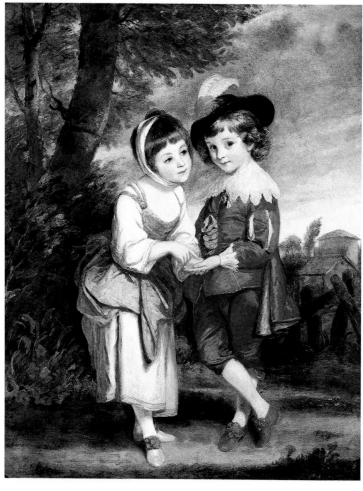

Sir Joshua Reynolds P.R.A. (1723–1792), *Jane, Countess of Harrington*, 1777–79, oil on canvas, 92¾ x 57in (235.6 x 144.8cm).

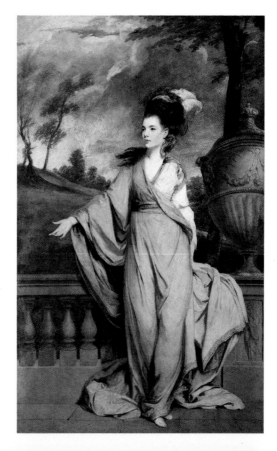

Sir Joshua Reynolds P.R.A. (1723–1792), *Lavinia, Countess Spencer, and Viscount Althorp*, 1783–84, oil on canvas, 57½ x 43in (146.1 x 109.2cm).

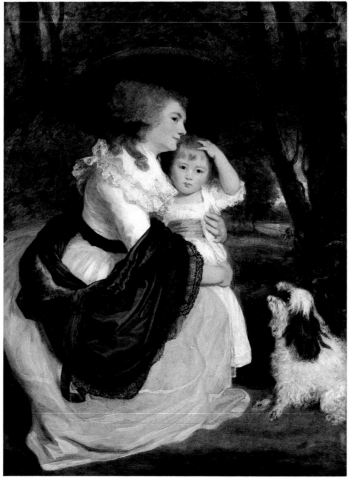

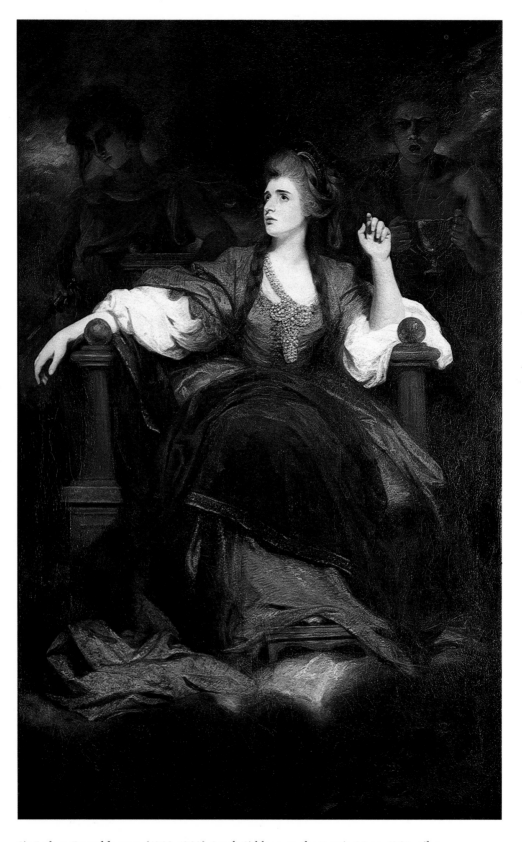

**Sir Joshua Reynolds** P.R.A. (1723–1792) *Sarah Siddons as the Tragic Muse*, 1784, oil on canvas, 93 x 57½in (236.2 x 146.1cm).

In this painting, considered by Reynolds and his contemporaries as his masterpiece, the artist portrays Mrs Siddons, the great tragic actress, with the attributes of Melpomene, the Muse of Tragedy. The painting is full of learned allusions to Aristotle, Michelangelo, treatises on the passions, and theories concerning "grand manner" painting. Reynolds manages to blend all this information together into a unified work of great dignity and power.

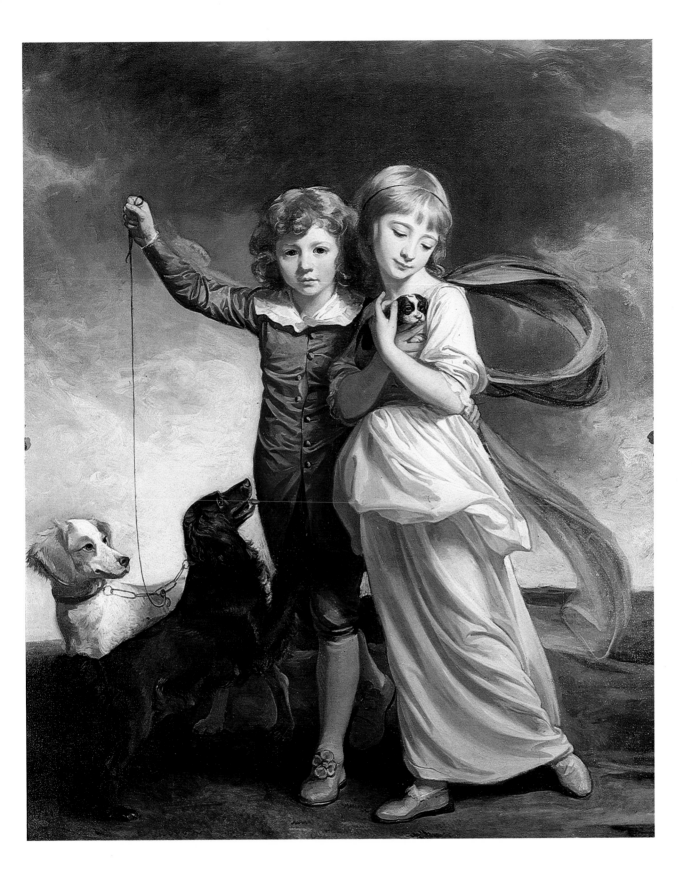

George Romney (1734–1802), *The Clavering Children*, 1777, oil on canvas, 60 x 48in (152.4 x 121.9cm).
This portrait was painted shortly after Romney's return from a period of study in Italy. The careful placement of the figures; the echoing curves of the scarf, the boy's arm, the back of the dog, all attest to the artist's study of antique Roman bas reliefs and wall paintings.

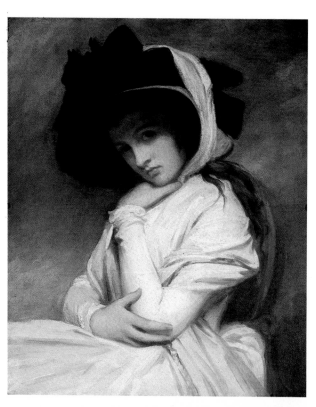

George Romney (1734–1802), *Lady Hamilton in a Straw Hat*, painted not later than 1785, oil on canvas, 29½ x 24½in (74.9 x 62.2cm). This charming portrait of the mistress of Lord Nelson was probably painted in the early 1780s before she had met either Nelson or her future husband, Sir William Hamilton. She was at the time under the "protection" of Sir William's nephew, Charles Greville.

John Hoppner R.A. (1758–1810), *The Godsal Children: The Setting Sun*, 1789, oil on canvas, 54 x 60½in (137.2 x 153.7cm).

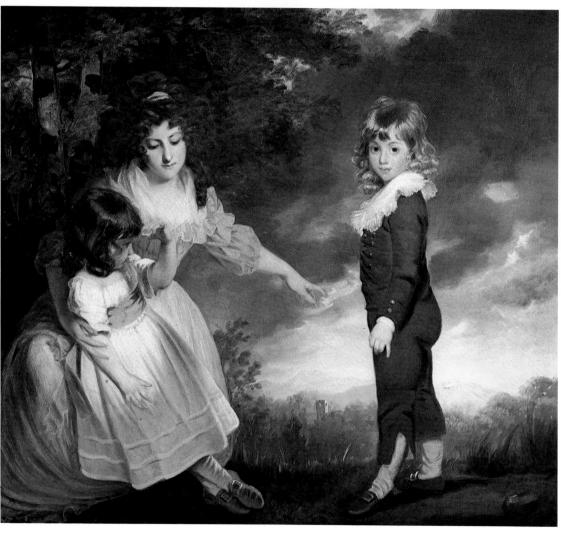

Richard Cosway (1742–1821), *George, Prince of Wales*, 1787, watercolor on ivory, 3½ x 2¾in (8.9 x 7cm), oval.
Cosway represents his friend and patron, the Prince of Wales, while still a young man, although already notorious for his numerous amours and profligate ways. The miniature is a beautiful example of the light, feathery touch which is a distinctive feature of Cosway's work.

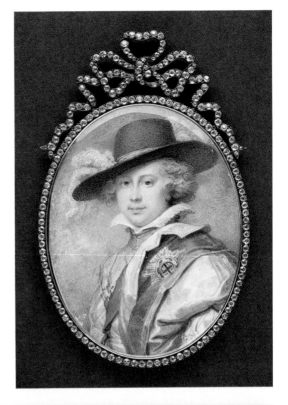

Francis Wheatley R.A. (1747–1801), *Mrs Ralph Winstanley Wood and Her Two Daughters*, 1787, oil on canvas, 36 x 28½in (91.4 x 72.4cm).

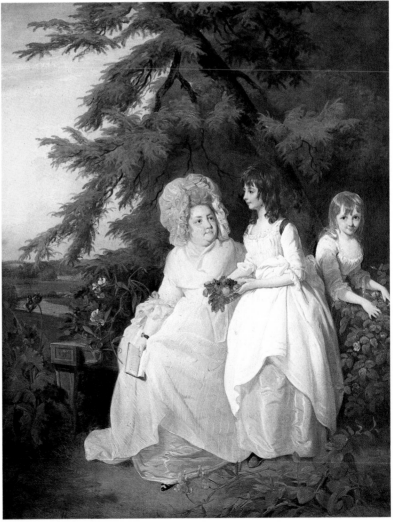

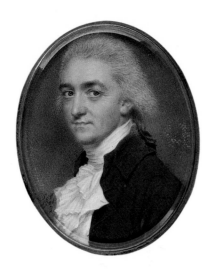

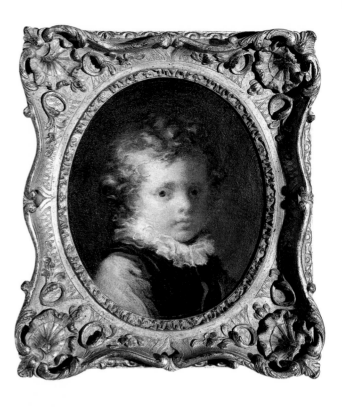

John Smart (1741–1811), *Robert Woolf (the artist's son-in-law)*, 1786, watercolor on ivory, 2 x 1½in (5.1 x 4cm).

Jean-Honoré Fragonard (1732–1806), *Head of a Boy* (probably the artist's son), oil on canvas, 8½ x 7¼in (21.6 x 18.4cm), oval.

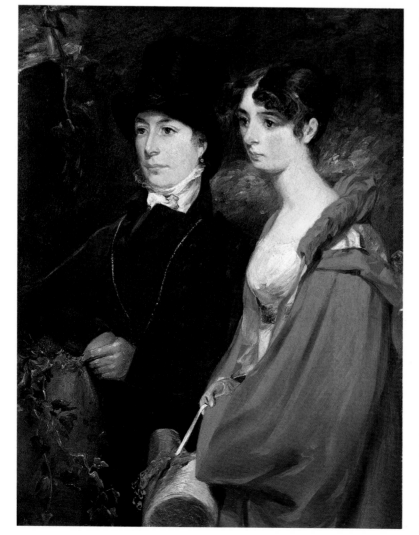

John Constable R.A. (1776–1837), *The Artist's Sisters, Anne and Mary Constable*, c.1818, oil on canvas, 15 x 11½in (38.1 x 29.2cm). Constable painted a few portraits, especially early in his career. The best are those of close friends and family. In this portrait of his two sisters Constable uses costume effectively to emphasize the different personalities of the two women.

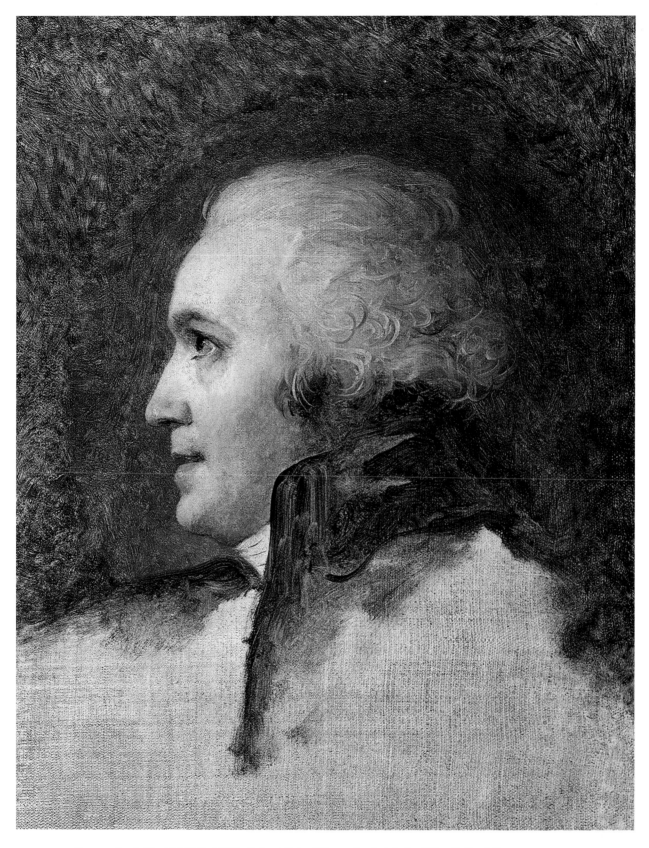

Jacques-Louis David (1748–1825), *Rabaut Saint-Etienne* (a sketch for "The Oath of the Tennis Court"), oil on canvas, 21¾ x 16¾in (55.2 x 42.5cm).
This spirited portrait sketch was made by David in preparation for a large painting he never completed commemorating the famous "Oath in the Tennis Court" at the onset of the French Revolution. Rabaut Saint-Etienne was active in gaining tolerance for French Protestants. Like so many of the moderate early revolutionaries, he fell from favor and was guillotined in 1793.

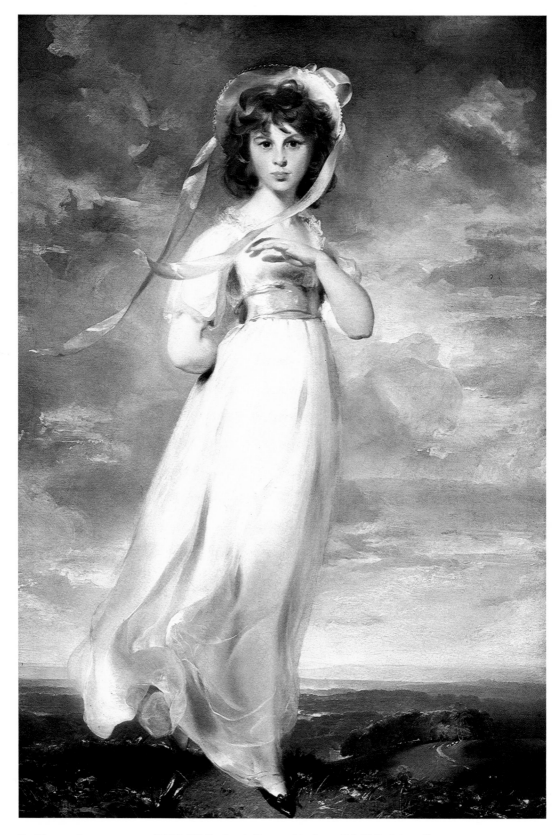

Sir Thomas Lawrence P.R.A. (1769–1830), *Sarah Barrett Moulton: "Pinkie"*, 1794, oil on canvas, 57½ x 39¼in (146.1 x 99.7cm).
Pinkie's proper name was Sarah Goodin Barrett Moulton. She was born in Jamaica. The portrait was painted on commission from her grandmother in Jamaica when Pinkie (who was so nicknamed by her family) came to England with her brothers to continue her education. She died, apparently of tuberculosis, within a few months of the completion of the portrait. Her brother, who changed his surname to Moulton-Barrett, was the father of the poet Elizabeth Barrett Browning.

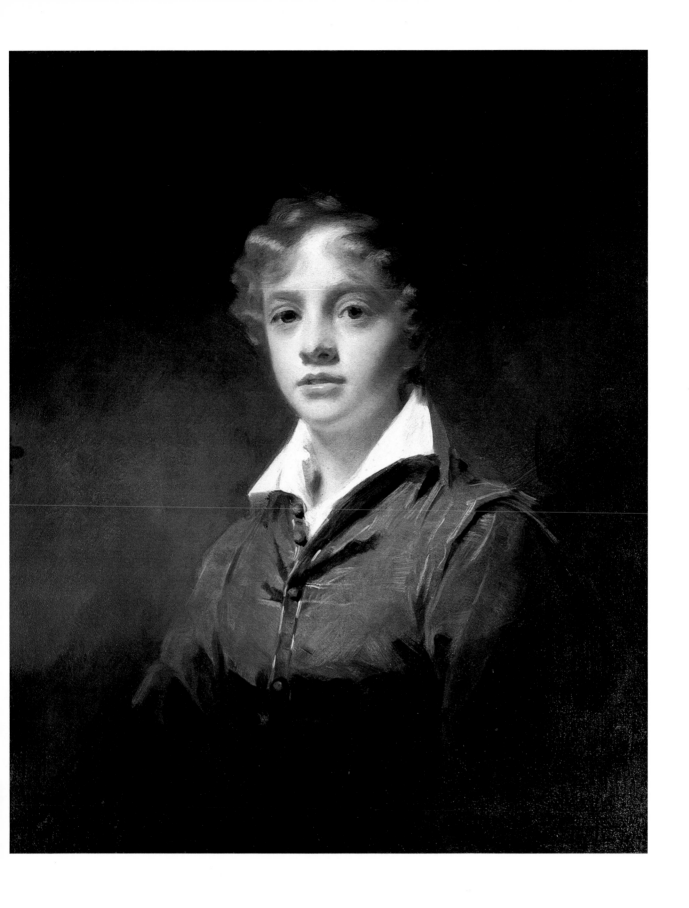

Sir Henry Raeburn R.A. (1756–1823), *Master William Blair*, c.1814, oil on canvas,
29½ x 24¾in (74.9 x 62.9cm).

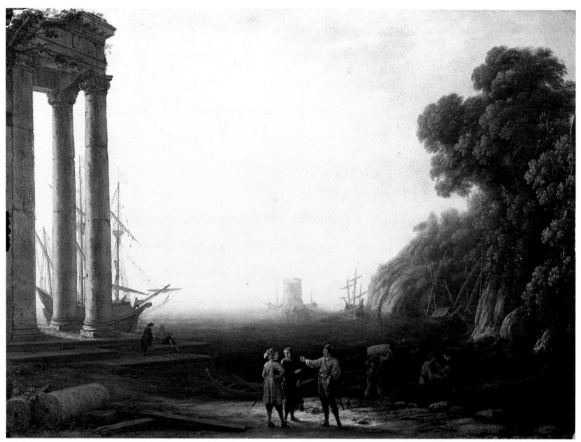

Claude Gellée (Le Lorrain) (1600–1682), *Seaport at Sunrise*, 1636, oil on canvas,
28½ x 38in (72.4 x 96.5cm).

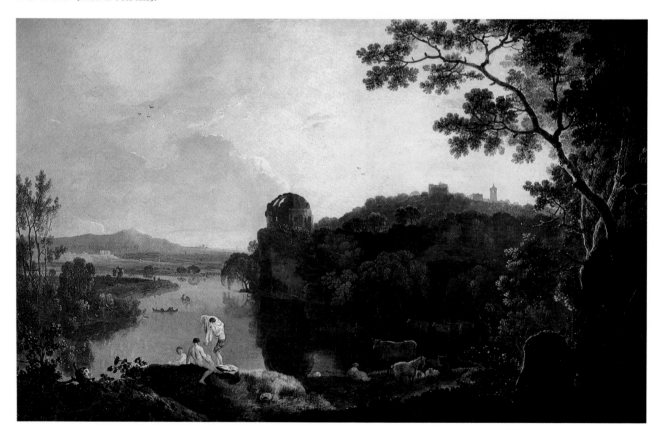

Richard Wilson R.A. (1714–1782), *River Scene: Bathers and Cattle*, c.1770–75, oil on canvas,
35⅛ x 56⅛in (89.2 x 142.6cm).

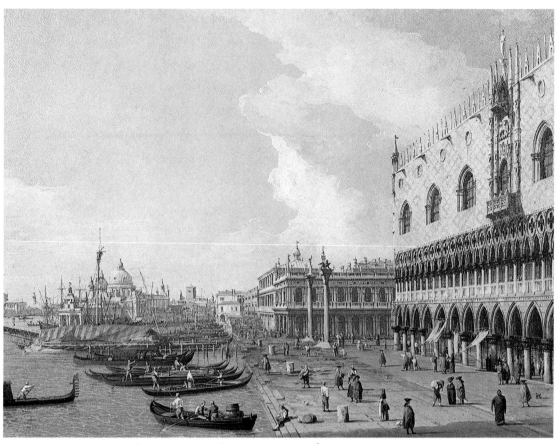

Antonio Canal (called Canaletto) (1697–1768), *View in Venice*, oil on canvas, 18⅛ x 24¾in (46 x 62.9cm).

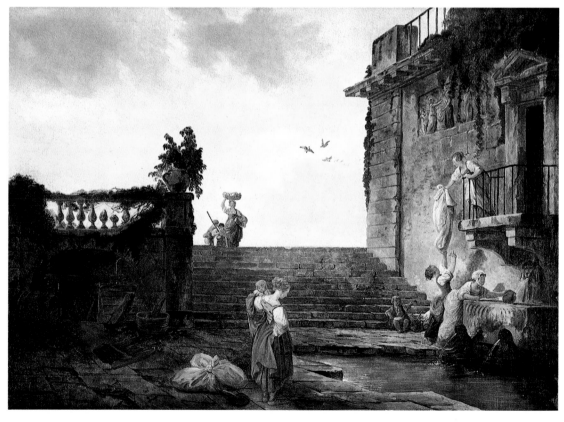

**Hubert Robert** (1753–1801), *Women Washing at a Fountain*, oil on canvas, 32 x 46in (81.3 x 116.8cm).

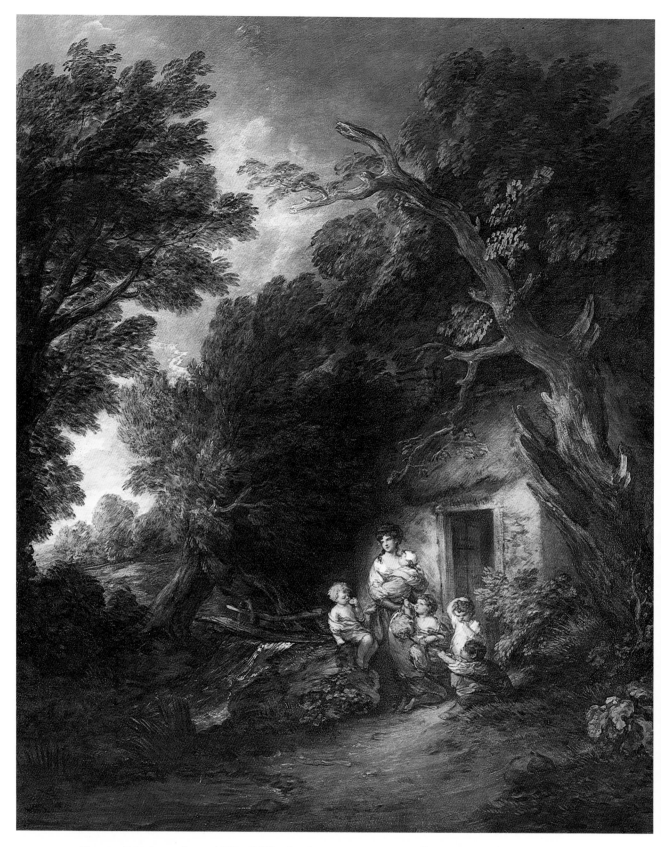

**Thomas Gainsborough** R.A. (1727–1788), *The Cottage Door*, *c*.1780, oil on canvas,
58 x 47in (147.3 x 119.4cm).
Gainsborough was haunted through the later part of his career by the image of a family
gathered around the door of a country cottage. He painted numerous variations
on the theme with different groupings of the figures and different emotional overtones.
The Huntington version, which is probably the best-known of the series, is unusual
in the composition of the group and the clarity of the tent-like composition.

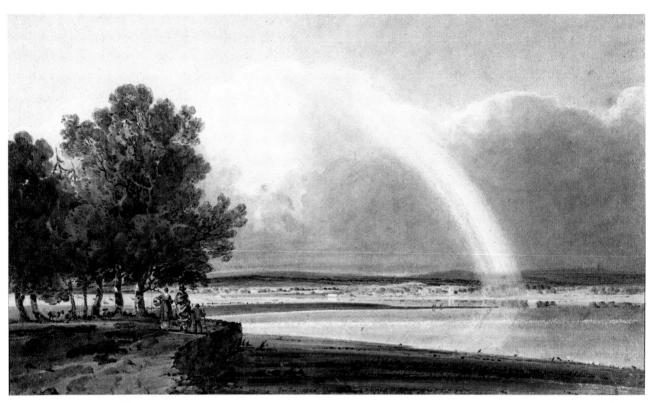

Thomas Girtin (1775–1802), *Rainbow on the Exe*, 1800, watercolor, 11½ x 19¾in (29.2 x 50.2cm).

John Sell Cotman (1782–1842) *A Thatched Cottage*, watercolor, 8¾ x 12⅝in (22.2 x 32.1cm).

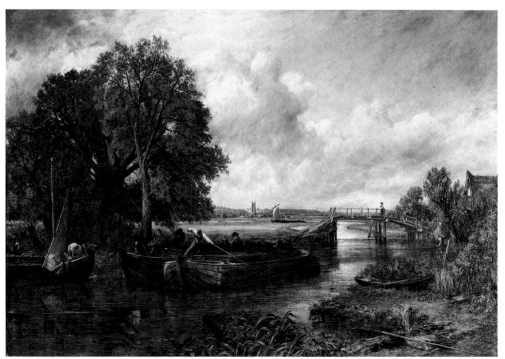

John Constable R.A. (1776–1837). *View on the Stour near Dedham*, 1822, oil on canvas, 51 x 74in (129.5 x 188cm). This is one of a series of six large canvases Constable painted between 1819 and 1825. Each is approximately four-and-a-half by six feet. All represent views on the river Stour within two or three miles of the place Constable was born and brought up. They are the culmination of Constable's art, demonstrating as they do his concern with capturing subtle variations in light and weather as revealed through quiet stretches of the English countryside.

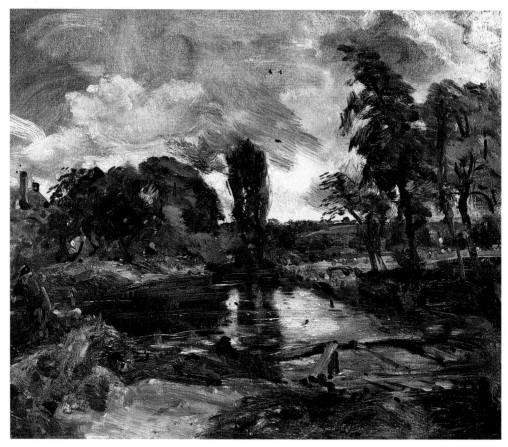

John Constable R.A. (1776–1837), *Flatford Mill from the Lock*, 1810 or 1811, oil on canvas, 10 x 12in (25.4 x 30.5cm).

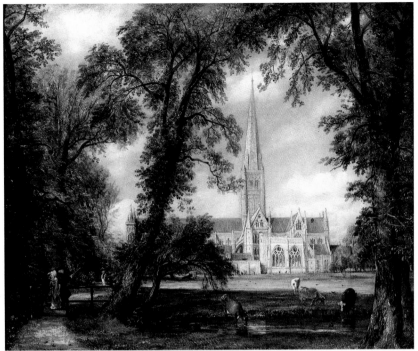

John Constable R.A. (1776–1837), *Salisbury Cathedral*, 1823, oil on canvas, 25 x 30in (63.5 x 76.2cm).

Constable painted at least three versions of this subject. The Huntington picture was done on commission from the Bishop of Salisbury as a wedding present for his daughter. The bishop and the painter had a difference of opinion about the sky. The bishop maintained that, as the picture was to be a wedding present, he wanted a sunny sky without the rolling, ominous, cumulus clouds that Constable liked to include in his paintings.

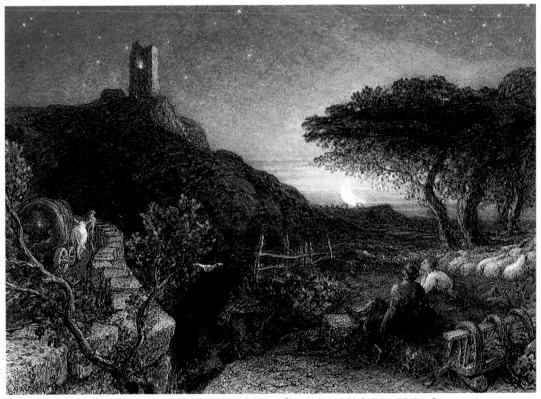

Samuel Palmer (1805–1881), *The Lonely Tower*, watercolor, 6⅝ x 9¼in (16.8 x 23.5cm).
The watercolor is a preliminary study for an etching completed by Palmer in 1879. The subject is an illustration to Milton's poem *Il Penseroso*:

> Or let my Lamp at midnight hour,
> Be seen in some high lonely Towr,

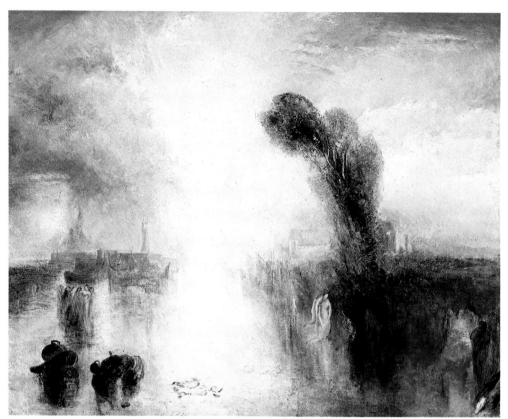

Joseph Mallord William Turner R.A. (1775–1851), *Beaumaris Castle, Anglesey*, watercolor, 11⅝ x 16¾in (29.5 x 42.5cm).

Joseph Mallord William Turner R.A. (1775–1851), *Neapolitan Fisher-Girls Surprised Bathing by Moonlight*, c.1840, oil on canvas, 25½ x 31½in (64.8 x 80cm).

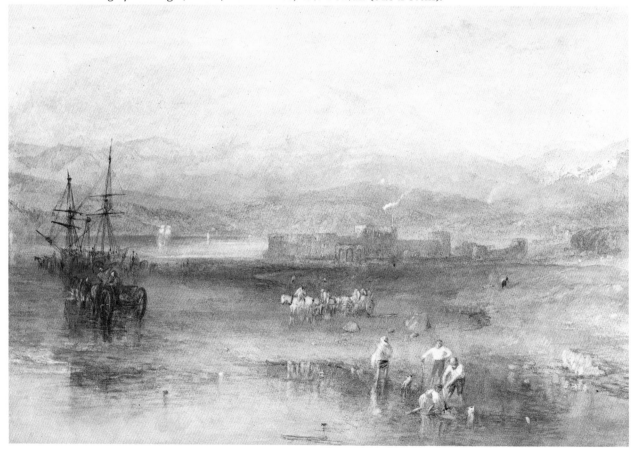

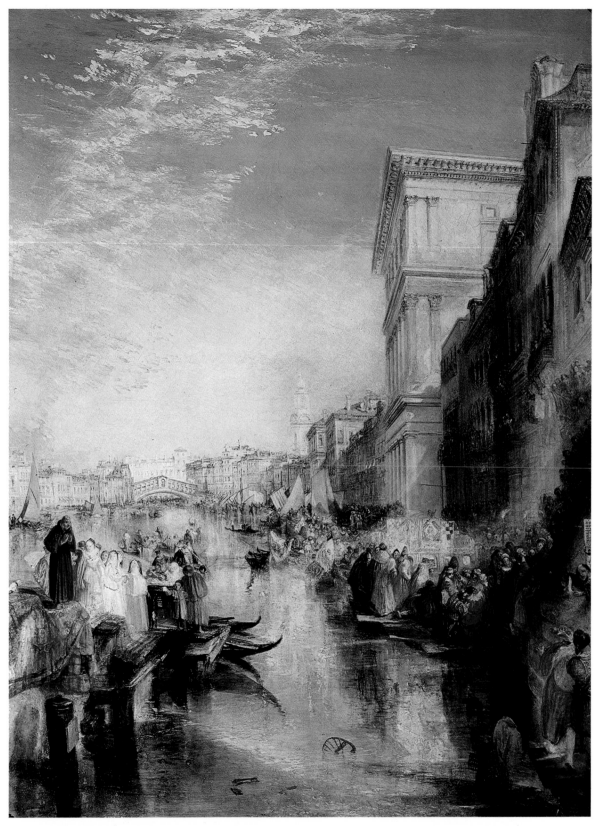

**Joseph Mallord William Turner** R.A. (1775–1851), *The Grand Canal, Venice: Shylock, c.*1837, oil on canvas, 58¼ x 43½in (148 x 110.5cm).
Turner frequently includes literary and historical allusions in his pictures, although he often did so in a capricious way. In this painting Shylock is tucked off in the lower right corner, leaning out of a window with his paper, knife, and measuring scales. But Turner was less interested in illustrating any particular scene from *The Merchant of Venice* than he was in evoking the general mood of Shakespeare's play with Venice as a bustling and glamorous commercial city.

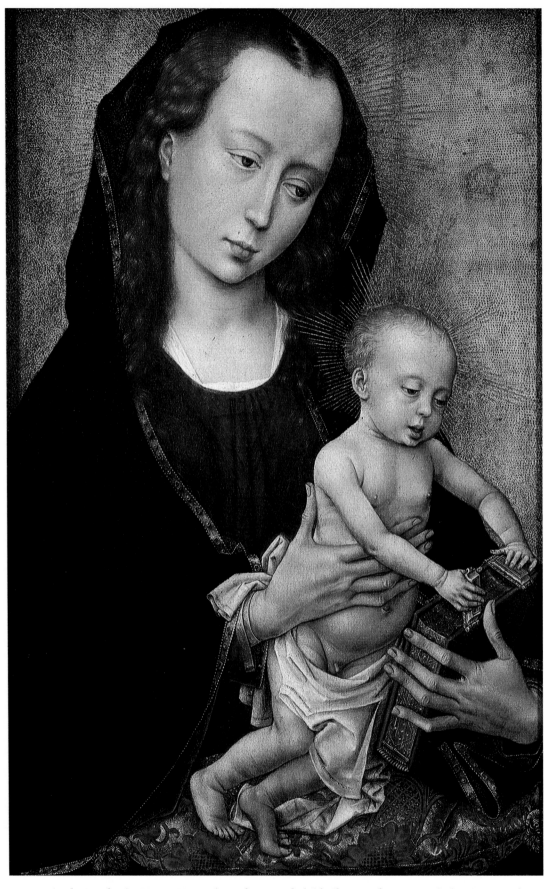

Roger van der Weyden (1399 or 1400–1464), *Madonna and Child*, oil on panel, 19½ x 12½in (49.5 x 31.8cm). The painting is the left-hand panel of a diptych of which the right leaf (representing the donor, Philippe de Croy, Seigneur de Sempy) is in the Koninklijk Museum, Antwerp.

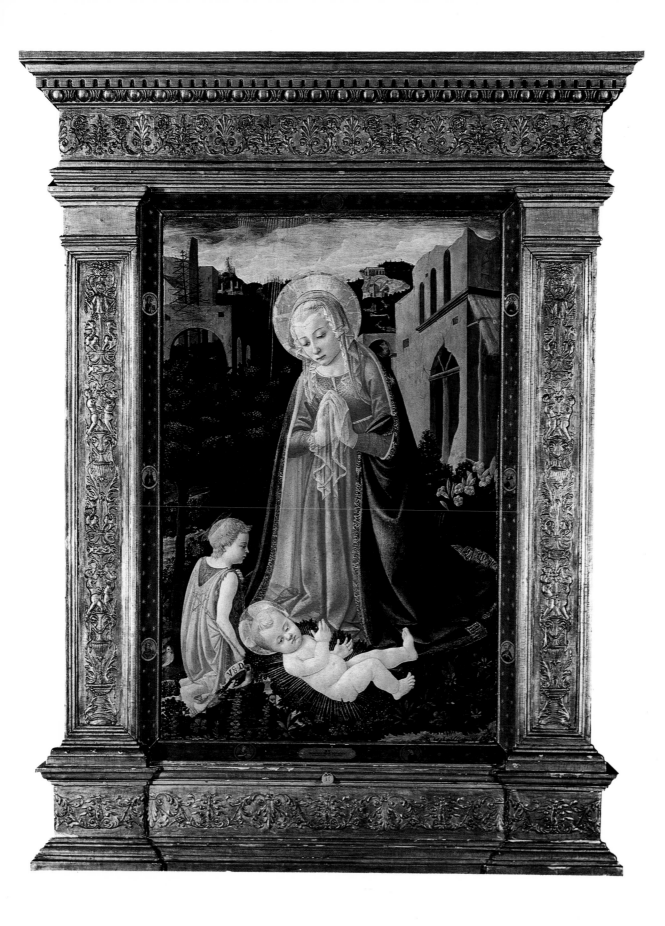

Master of the Castello Nativity (Florentine, end of the fifteenth century), *Madonna and Child with St John*, oil on panel, 43¾ x 30½in (111.1 x 77.5cm).

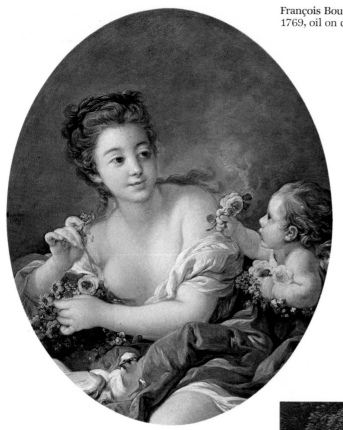

François Boucher (1703–1770), *Venus and Cupid*,
1769, oil on canvas, 27½ x 22½in (69.9 x 57.2cm), oval.

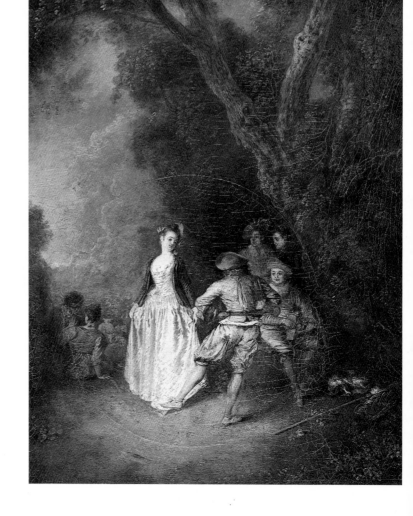

Antoine Watteau (1684–1721),
*La Danse Paysanne*, oil on panel,
17 x 12¾in (43.2 x 32.4cm).

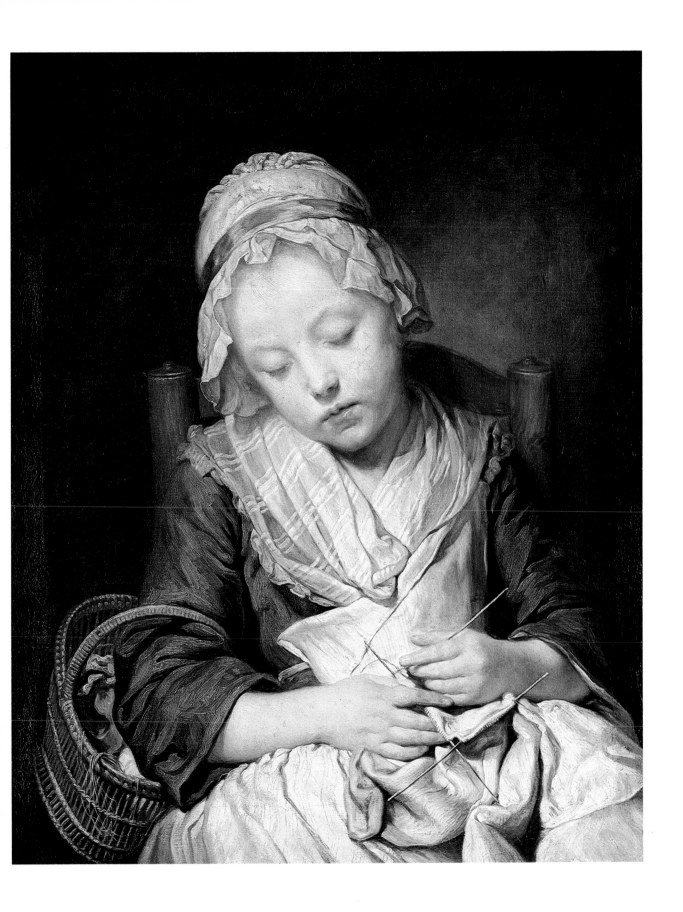

Jean-Baptiste Greuze (1725–1805), *Young Knitter Asleep*, oil on canvas, 26¾ x 21¾in (67.9 x 55.2cm).

**William Blake** (1757–1827), *The Conversion of Saul, c.*1800, watercolor, 16⅛ x 14⅛in (41 x 35.9cm).

The Huntington is fortunate to own an outstanding collection of works by William Blake, including fifty-six drawings, paintings, and color prints by or attributed to Blake.

*The Conversion of Saul* is a particularly well-preserved watercolor, having spent most of its life in an album, away from the damaging effects of sunlight.

Thomas Rowlandson (1756–1827), *A French Frigate Towing an English Man-o'-War into Port*, watercolor, 10½ x 8¼in (26.7 x 21cm).
The Huntington has over six hundred drawings by Thomas Rowlandson, probably the largest and most comprehensive collection of that artist's works in existence.

William Etty R.A. (1787–1849), *Still Life*, oil on panel, 12½ x 16¼in (31.8 x 41.3cm).

George Morland (1763–1804), *The Farmyard*, 1792, oil on canvas, 39½ x 55in (100.3 x 139.7cm).

Giovanni Bologna (1529–1608), *Nessus and Deianira*, bronze, H. 16⅜in (41.6cm). The mythological episode of the centaur, Nessus, carrying off Deianira, the wife of Herakles, provided Giovanni Bologna with a splendid opportunity to devise a composition with two forms in violent interaction. He made three versions (the two others are in the Louvre and the Grünes Gewölbe, Dresden). His followers continued to make countless repetitions of the popular subject.

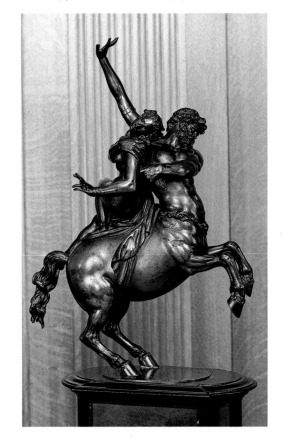

Benjamin Marshall (1767–1835), *Sam with Sam Chifney, Jr., Up*, 1818, oil on canvas, 40 x 50in (101.6 x 127cm).

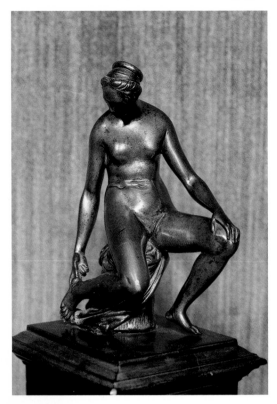

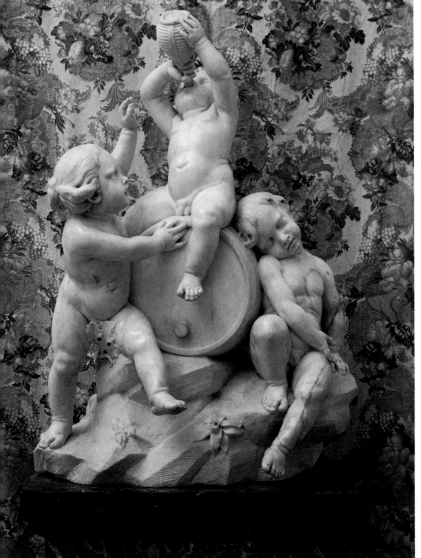

Bartolomeo Ammanati (1511–1592), attr., *Hercules*, bronze, H. 14⅝in (37.1cm).

Italo-Flemish (*c*.1600), *Woman Touching Her Foot*, bronze, H. 5in (12.7cm).

Louis François Roubiliac (*c*.1705–1762), *Bacchanal*, 1758, marble, H. 38in (96.5cm). Roubiliac, born and trained in France, is probably the most distinguished sculptor to spend the major portion of his career in England. He is known primarily as a portraitist, and is represented in that capacity in the Huntington collection by busts of Handel and Sir Peter Warren. The playful *Bacchanal*, which is signed and dated 1758, is unusual for Roubiliac, but is very much in the rococo mood of contemporary work by his French compatriots.

Giovanni Bologna (1529–1608), *Crouching* ▷ *Venus*, bronze, H. 9⅞in (25.1cm).

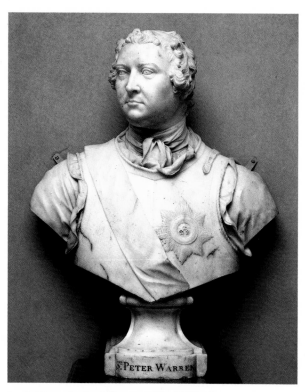

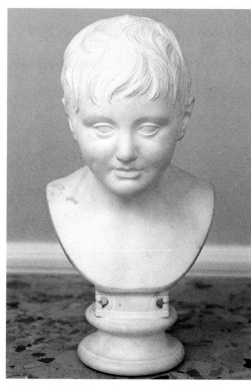

Louis François Roubiliac (*c*.1705–1762), *Sir Peter Warren*, marble, H. 33in (83.8cm).

Joseph Nollekens R.A. (1737–1823), *Head of a Boy*, 1796, marble, H. 16in (40.6cm) with base.

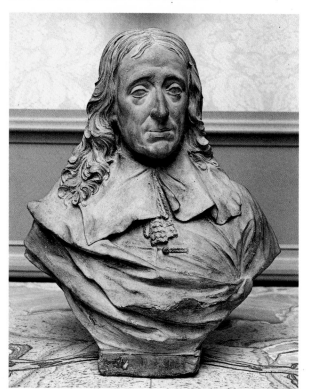

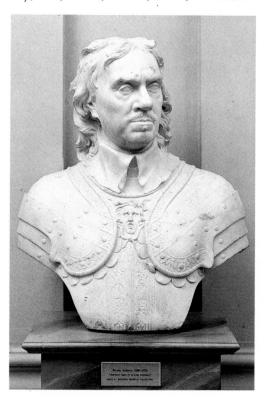

John Michael Rysbrack (1694–1770), *John Milton*, terra-cotta, H. 22in (55.9cm).

John Michael Rysbrack (1694–1770), *Oliver Cromwell*, marble, H. 24½ in. (61.6cm).

Rysbrack, born in the Low Countries, vies with Roubiliac for the position of the leading sculptor active in mid-eighteenth-century England. Known primarily as a portraitist, Rysbrack is particularly identified with busts of British worthies from earlier periods. All three of his works in the Huntington collection happen to be of mid-seventeenth-century men: Milton, Cromwell, and John Hampden. The Milton bust is similar to the marble bust on the Milton monument in Westminster Abbey designed by Rysbrack and erected in 1738.

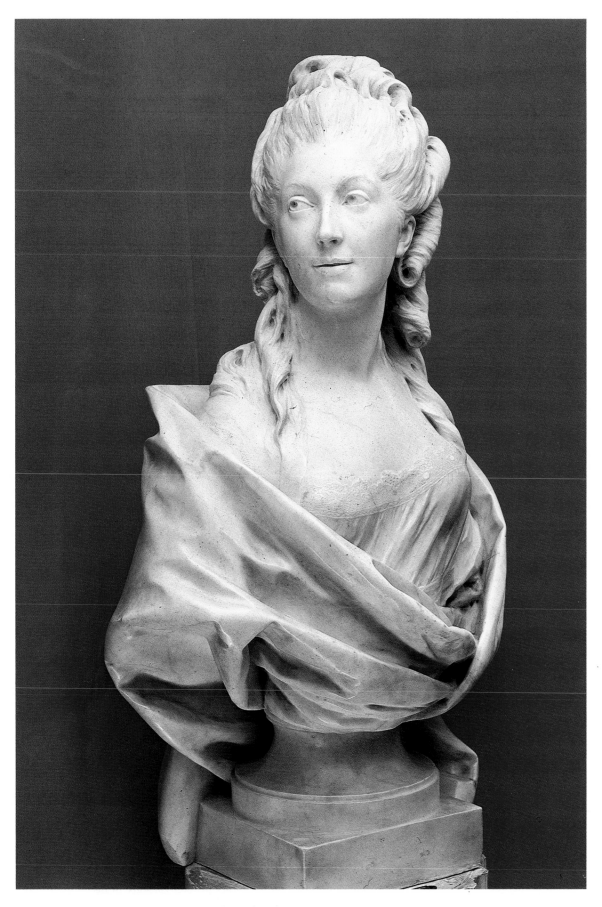

Jean-Antoine Houdon (1741–1828), *Portrait of a Lady* (so-called Baroness de la Houze), 1777, marble, H. 39in (99.1cm).

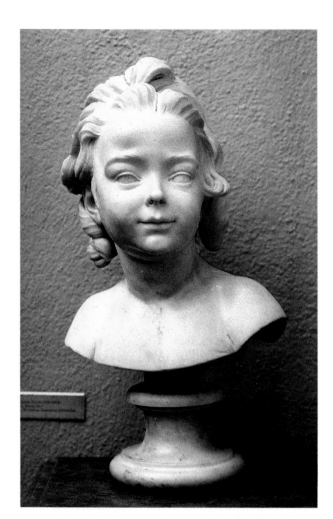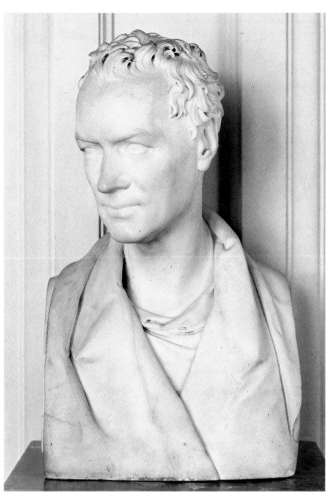

Louis-Claude Vassé (1716–1772), *Bust of a Girl*, marble H. 18½in (47cm).

Sir Francis Chantrey R.A. (1781–1841), *William Howley, Archbishop of Canterbury*, 1832, marble, H. 22in (55.9cm).

Jean-Antoine Houdon (1741–1828), *Sabine Houdon*, marble H. 17¾in (45.1cm).  ▷

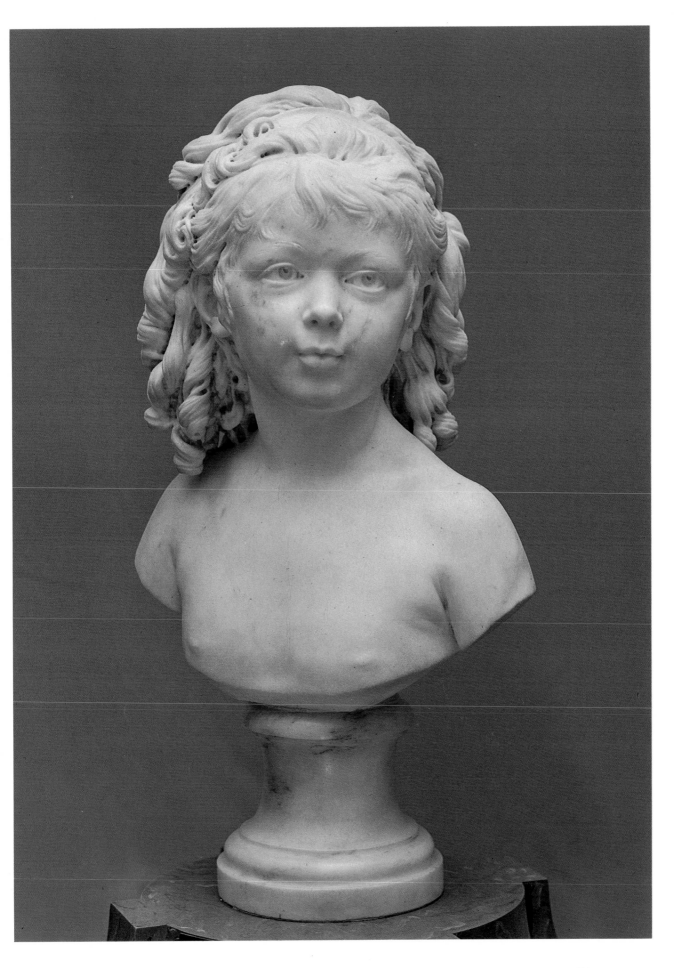

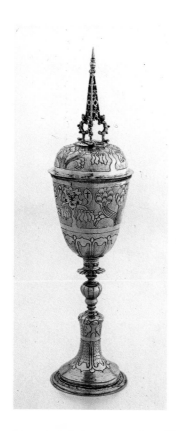

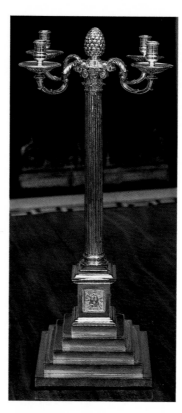

Silver-Gilt Standing Cup and Cover (Steeple Cup), London, 1661, maker's mark: AF, H. 19in (48.3cm).

Silver Candelabra, a pair, London, 1765, maker; Thomas Heming, H. 29¼in (74.3cm).

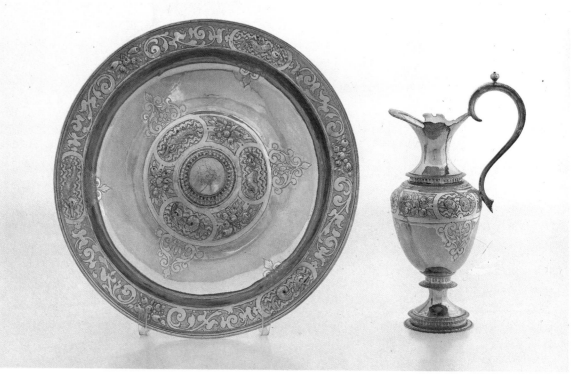

Silver-Gilt Rosewater Ewer and Basin, London, 1607, maker's mark: IA, ewer H. 14⅜in (36.5cm), basin D. 17⅞in (45.2cm).
This elaborately decorated ewer and basin is an example of a work of art created from a hygienic necessity. Before the days of forks (which did not come into common use in England until the late seventeenth century) much eating was done with the fingers. Hence it was necessary to wash the hands before rising from the table. Servants, approaching the guests in order of precedence, poured scented water from the ewer over the hands into the basin held below.

Clodion (Claude Michel) (1738–1814), *Woman Playing with a Child*, terra-cotta, H. 18in (45.7cm). ▷

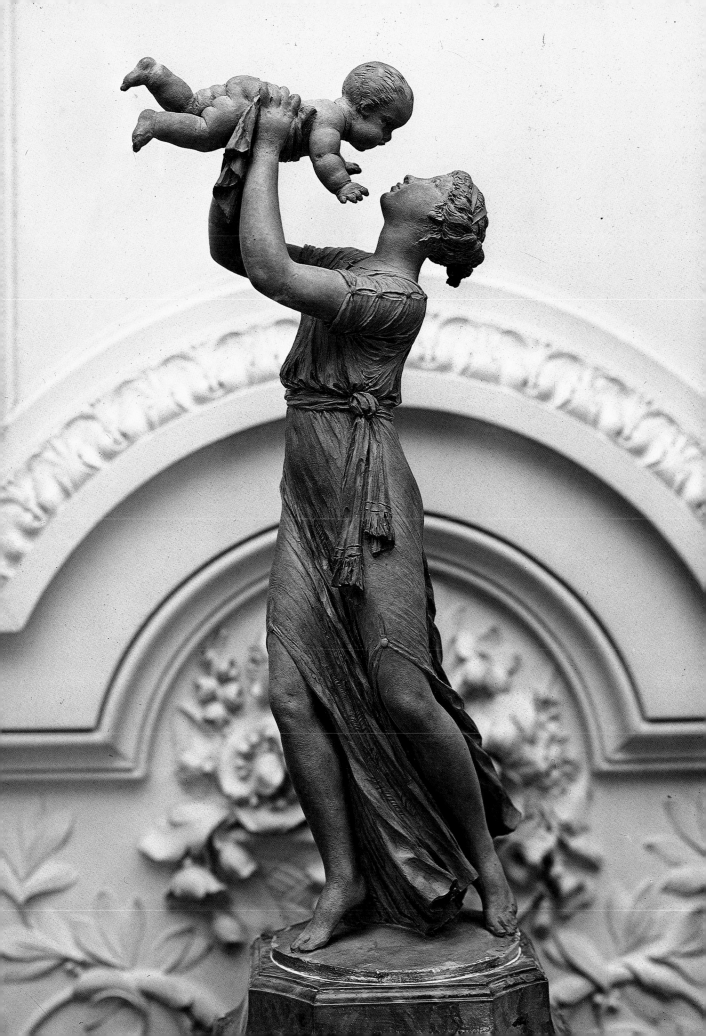

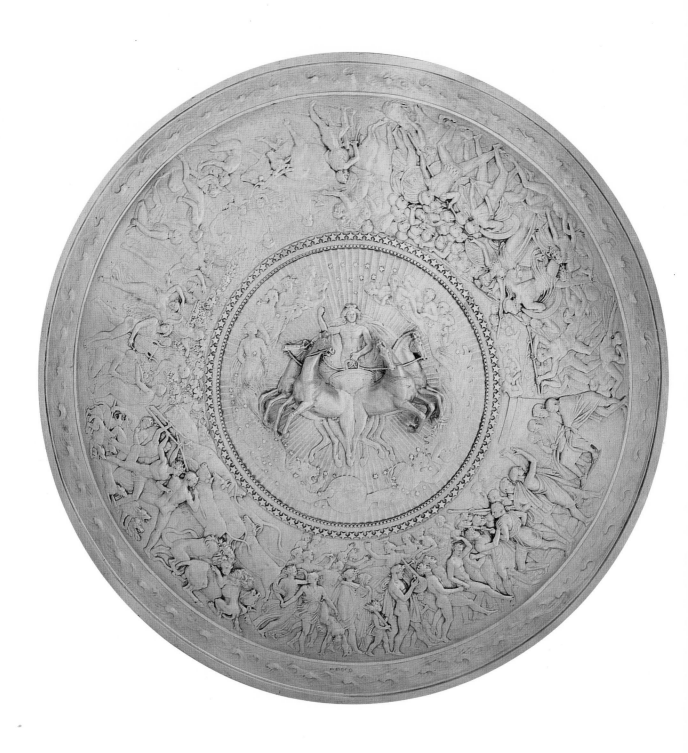

John Flaxman R.A. (1755–1826), *The Shield of Achilles*, 1821, silver-gilt, cast by Rundell, Bridge & Rundell, diam. 36½in (92.7cm).

When modelling the Shield of Achilles, Flaxman followed carefully the long description contained in Book XVIII of Homer's *Iliad*. The work, which Flaxman's contemporaries considered his masterpiece, was originally modelled in plaster. From the plaster, four silver-gilt casts were made, for George IV, the Duke of York, the Duke of Northumberland, and Lord Lonsdale. The Huntington cast is the one made for the Duke of York.

# THE GARDENS

in shapes, with species here from all parts of the world. The area provides a welcome, dappled shade and views of the broad lawns leading to the Art Gallery and Library.

Throughout the Huntington gardens, sculptures and other ornaments provide artistic accents. A grouping of figures may create a formal design, or a single piece may be almost hidden in its setting, discovered by those who take time to observe. Especially amusing are the faces and creatures on the dozen or more fountains: the dolphins of the grand Renaissance fountain in the North Vista, fish-tailed mer-horses on the Library fountain, stone birds perched as real as life on one near the Rose Garden, a lion's face on another half-hidden by Art Gallery landscaping.

Activities in the gardens include talks and tours, demonstrations of techniques like rose pruning or shaping the bonsai trees, performances of drama or dance under the sky. Staff and visiting specialists study and experiment with rare plant varieties, while others teach and learn the arts of garden design. The Huntington maintains an active exchange of plants, cuttings, and dried herbarium specimens with gardens all over the world: a seed list is always available, and special requests of botanists are answered whenever possible. Dozens of unusual plants have been introduced into cultivation by the Huntington; many are also propagated and sold to visitors along with background information on their origins and care. The gardens are a mecca for all those who come with scientific curiosity or just in search of nature's ever-changing beauty and appeal.

Landscaped with select trees and colorful annuals, the Pavilion welcomes Huntington visitors to enter through its broad arcade. Informative displays are arranged in the spacious open area. The featured tree (right of center) is the spiny-trunked floss silk tree (*Chorisia*).

A large stone fountain with spouting horses (a copy of a sixteenth-century Venetian fountain) occupies a central position in front of the Library.

Shades of green enhance the cool elegance of the Library façade.

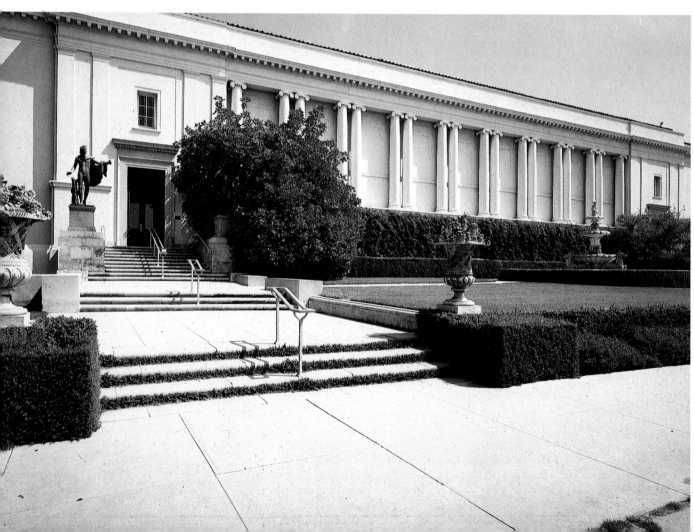

The broad South Terrace of the Art Gallery, at the crest of a hill, overlooks lawns and gardens below.

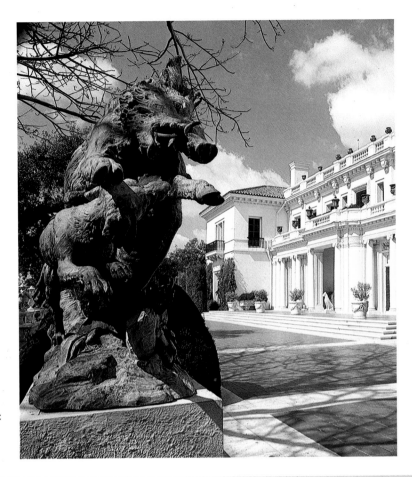

Viewed across the spreading lawns, the Art Gallery is landscaped with rare plants: on the right, cycads, and center, the Australian flame tree (*Brachychiton acerifolius*).

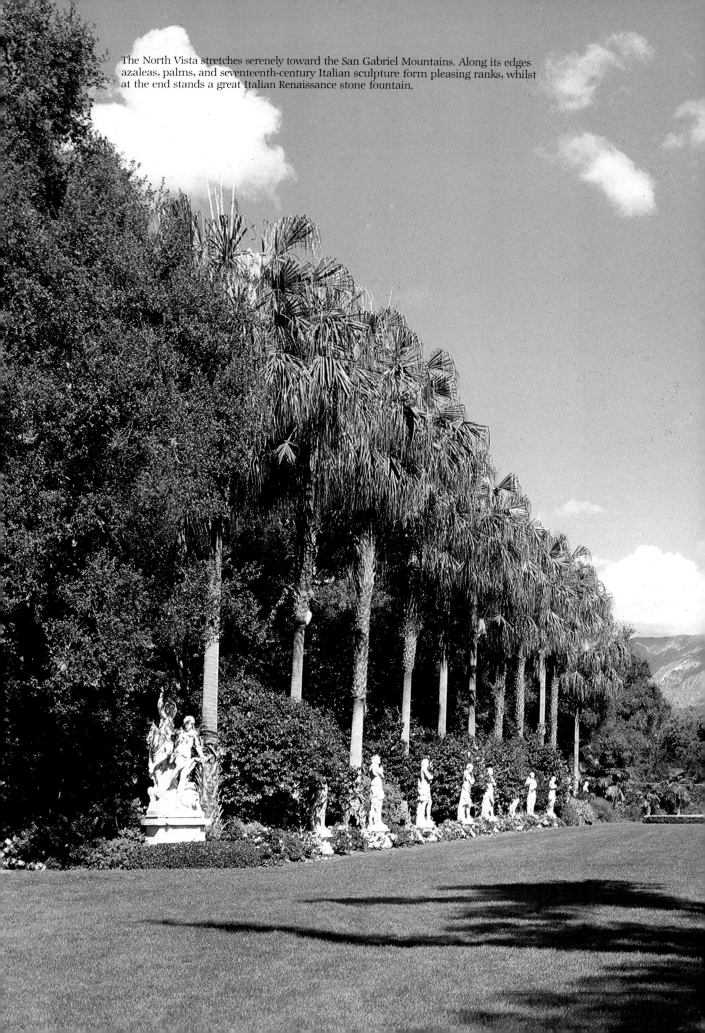

The North Vista stretches serenely toward the San Gabriel Mountains. Along its edges azaleas, palms, and seventeenth-century Italian sculpture form pleasing ranks, whilst at the end stands a great Italian Renaissance stone fountain.

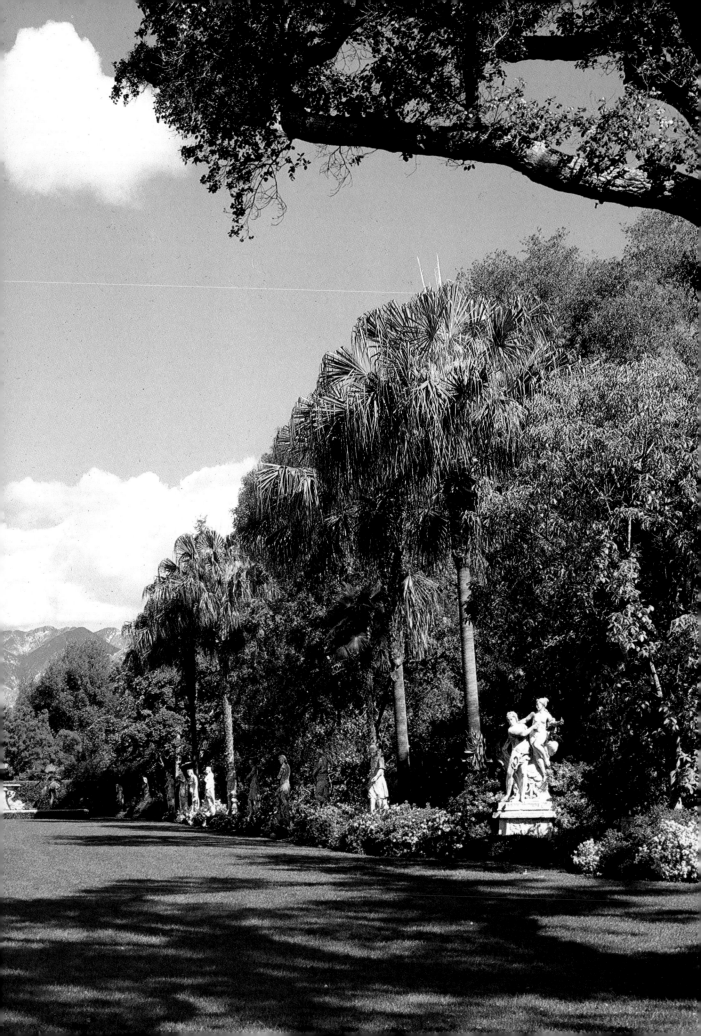

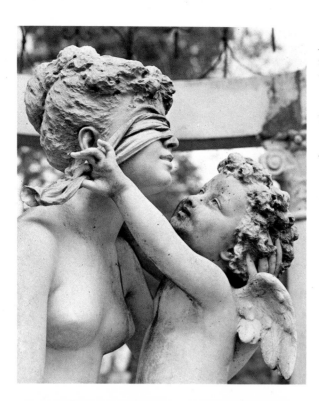

A wrought-iron temple near the North Vista holds this nineteenth-century marble statue, "Cupid Blindfolding Youth".

On a closer look, the North Vista fountain reveals four of these scaly sea-creatures.

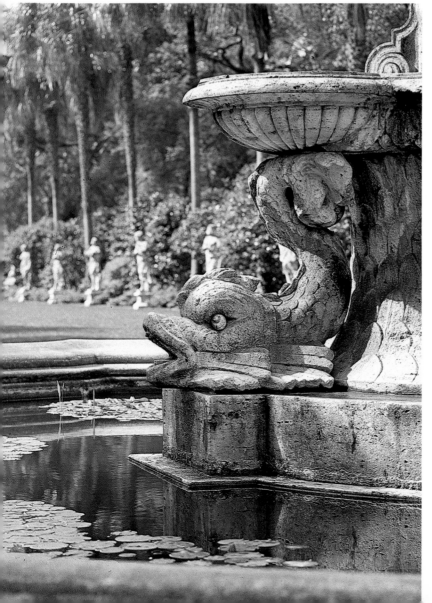

This tempietto, surrounded by azaleas and camellias, is one of the most charming ornaments in the camellia garden.

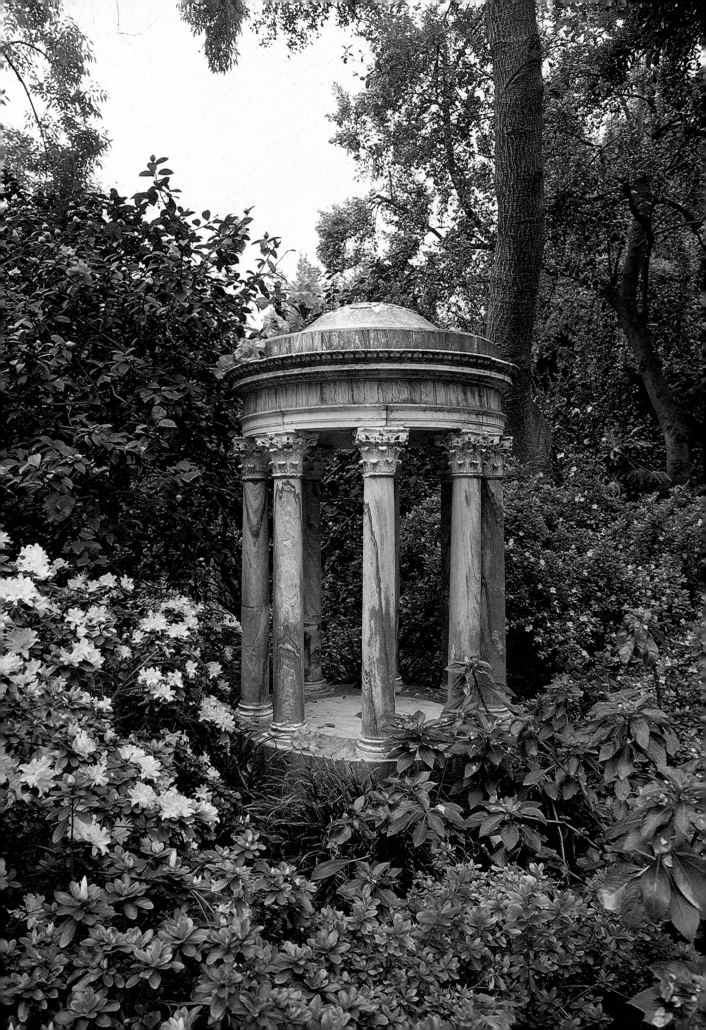

Deep in the camellia garden, the mood is that of an enchanted forest. Native oaks shade azaleas, fuchsias, and impatiens, whilst many of the camellias are themselves as tall as trees.

Spring comes early, with trees all over the gardens succeeding each other in bloom. Here, the flowering cherry (*Prunus ohami*) on a lane behind the North Vista.

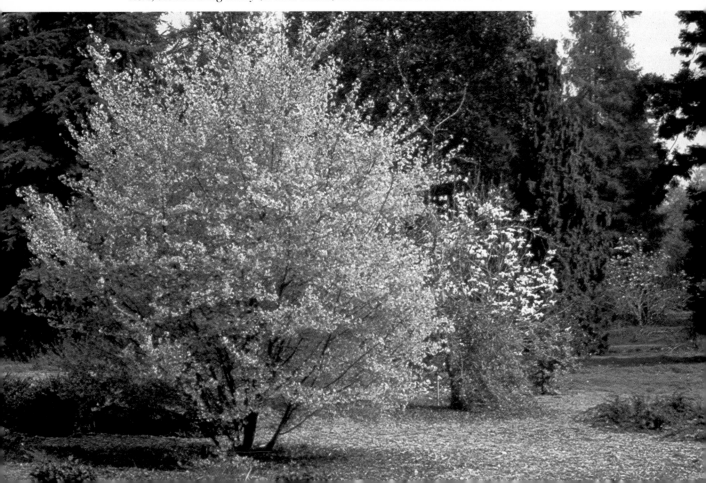

From the 1,500 varieties of camellias in the Huntington gardens, experts selected these beauties as a representative sampling:

C. *japonica* "Little Michael"
(anemone form)

Saluensis hybrid "Anticipation"
(peony form)

C. *japonica* "Nuccio's Gem"
(formal)

C. *japonica* "Betty's Beauty"
(semi-double to rose form)

C. *japonica* "Hody Wilson"
(semi-double to rose form)

The Huntington gardens are full of faces: with mysterious smile this sculpture adorns a bench in the Rose Garden.

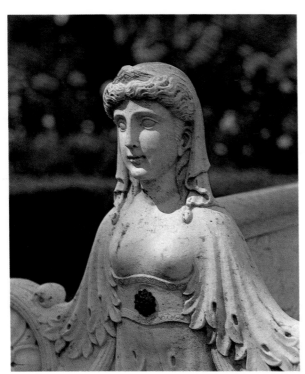

A towering Montezuma cypress makes ▷ a graceful backdrop for a stone temple wreathed by white roses.

Seen from any angle, the Rose Garden shows glorious masses of blooms. In this central section are the hybrid teas, the floribundas, the polyanthas, and the miniatures. Climbers flourish on pergolas and arches.

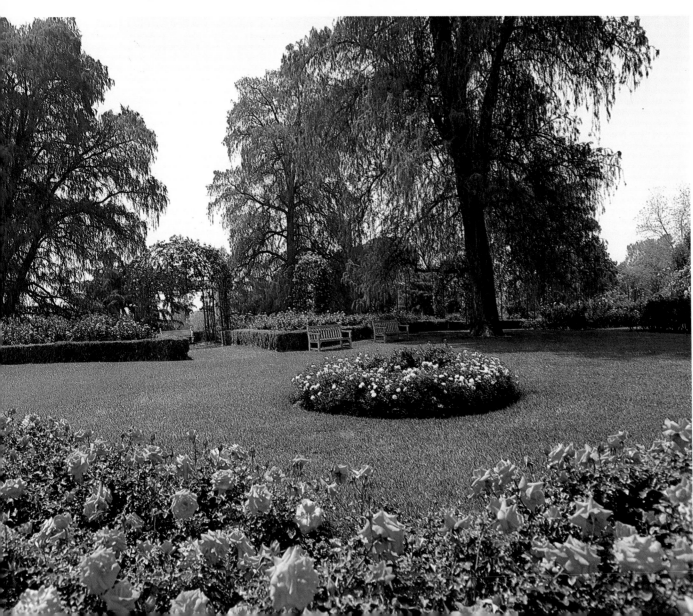

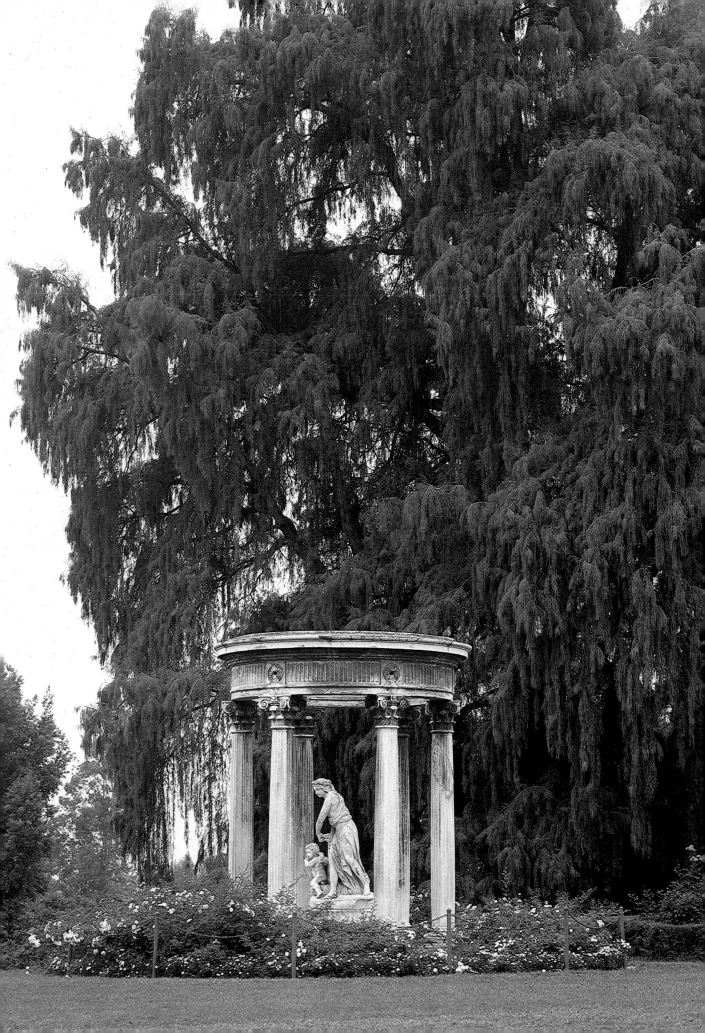

Who could choose a favorite among these gems from the collection?

"Rosa Foetida 'Bicolor'," long known as
"Austrian Copper". This rose from Central
Asia was brought to Western Europe
by the Moors, and was pictured in Gerard's
*Herball* in 1597.

"Lord Penzance," named for the hybridizer
who made numerous crosses in the
nineteenth century between the sweetbrier
or "Eglantine" and modern garden roses.
Its leaves are redolent of ripe Pippin apples.

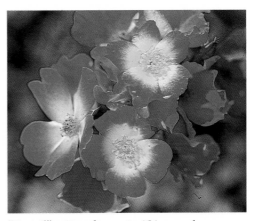

"Celsiana", a Damask rose grown in the
Netherlands during the seventeenth century.
It appeared in Rubens' painting *The Three
Graces* in 1640.

"Coctail", a French rose typifying modern
everblooming climbers.

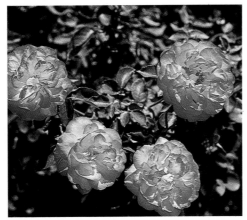

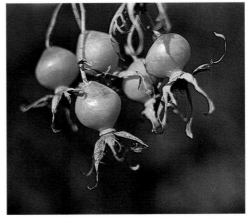

"Fantastique", a knee-high everblooming
border rose brought out in 1943. The lovely
sunset colors vary in response to sunlight
and temperature changes.

"Scharlachglut", or "Scarlet Fire", which
follows its spring blooming with a second
spectacular display of color in the fall:
these splendid fruits or "hips".

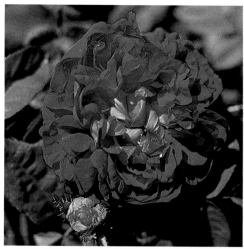

"Deuil de Paul Fontaine", typical of the Victorians' opulent taste in roses.

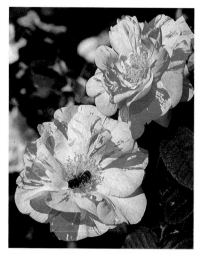

"Rosa Mundi", commemorating Sweet Rosamonde, mistress of King Henry II. A striped mutation from *Rosa gallica* "Officinalis", the "Apothecary's Rose", it is believed to be the oldest rose in cultivation.

Along the Huntington's Rose History Walk are planted more than a thousand species and cultivars of roses. This bouquet combines a sampling of the older garden roses – Gallicas, Centifolias, Bourbons, Hybrid Musks, and Teas. The frilly buds on top are the "Crested Moss Rose", also known as "Chapeau de Napoleon".

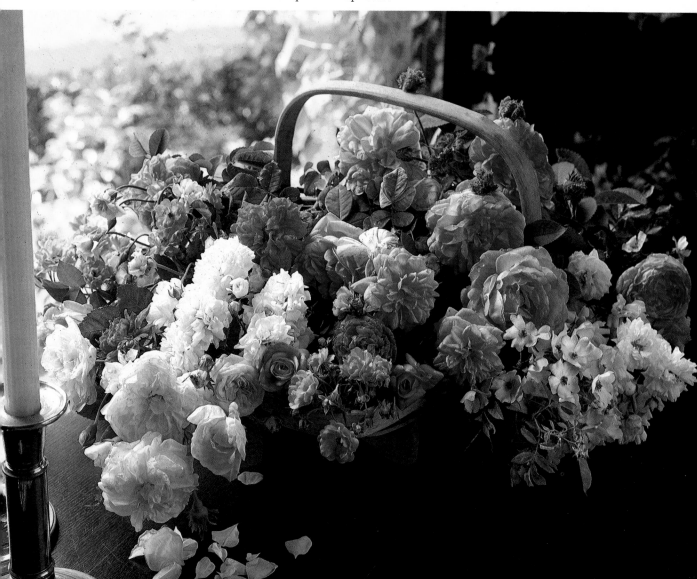

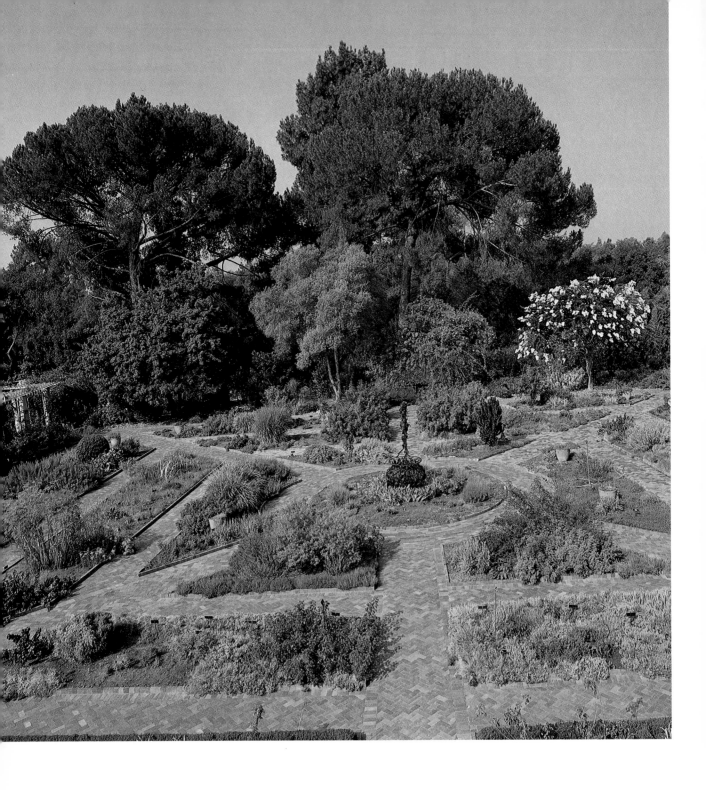

Viewed by a bird's eye, the Herb Garden spreads its age-old plants in orderly patterns.
Beyond the beds devoted to culinary, medicinal, cosmetic, and other herbs, a crepe
myrtle cools the sunny expanse with its drift of white.

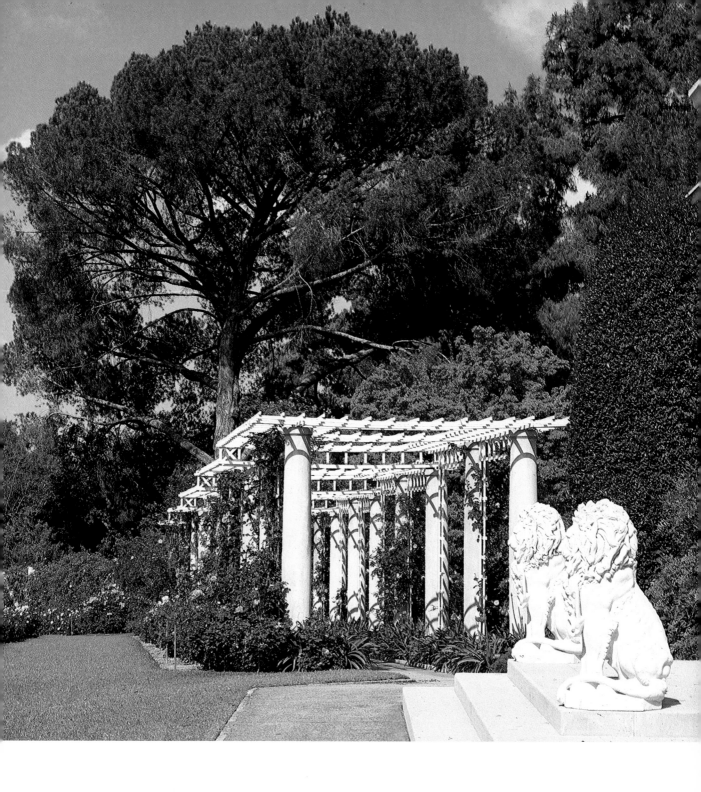

This arbor, planted with climbing roses, jasmine, and trumpet vines, invites the visitor to continue on to the Japanese Garden. Behind, an imposing stone pine dominates the skyline.

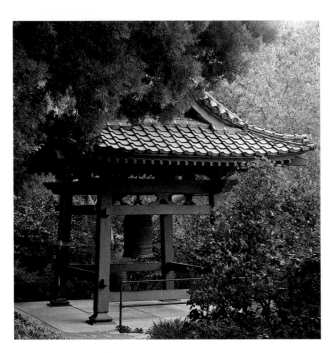

Near the entrance to the Japanese Garden, an eighteenth-century temple bell hangs in its tower. Its mellow voice is sounded by a striker made from the flower stem of the agave plant.

At the heart of the Japanese Garden, ▷ the vermilion moon bridge casts an arching reflection on the lake. Near the miniature shrine for the spirit of the lake, iris plants fringe the water's edge. Colorful koi add a touch of animation to the peaceful scene.

Surrounded by informal arrangements of azaleas and flowering fruit trees, the Japanese house overlooks the lake and bridge. Its simple interiors evoke a spiritual harmony. In nineteenth-century style, the rooms may be opened directly to the outdoors by moving outer walls.

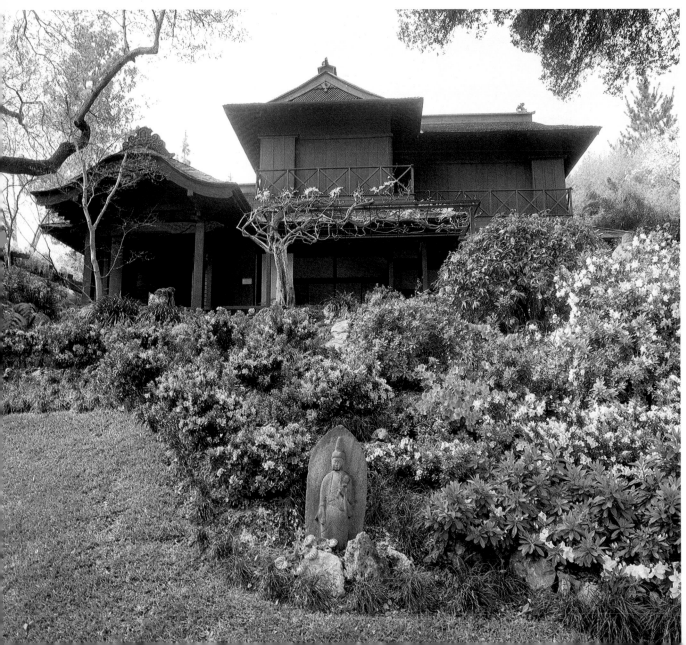

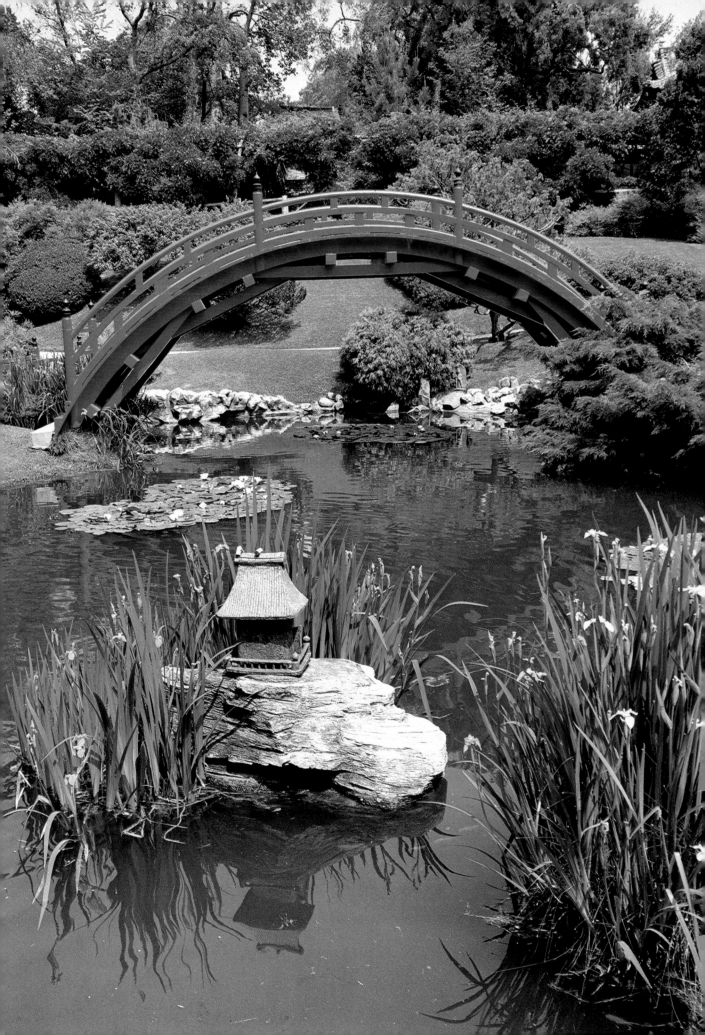

Near the house, a carved granite water-holding stone awaits a guest or provides water for the traditional washing which is part of the tea ceremony.

The Japanese Garden, having no broad vistas ▷ or symmetrical plantings, favors instead natural curves and forms. These masses of snowy azaleas are accented by the votive stone and pagoda, reminders of the Buddhist and Shinto philosophies alive in such a garden.

The fragrant wisteria bloom, on this arbor adjoining the Japanese house, is anticipated with pleasure every spring. Displayed in the background, left, are sui-seki: natural stones each suggesting a miniature landscape.

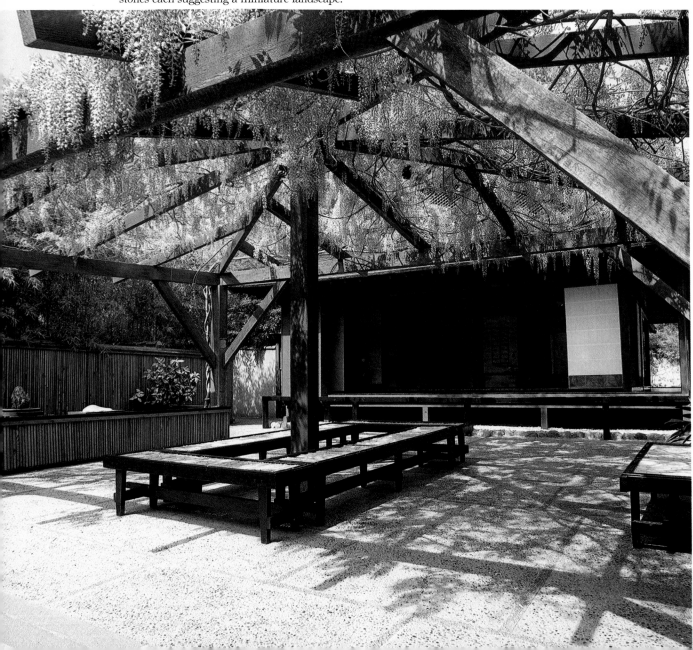

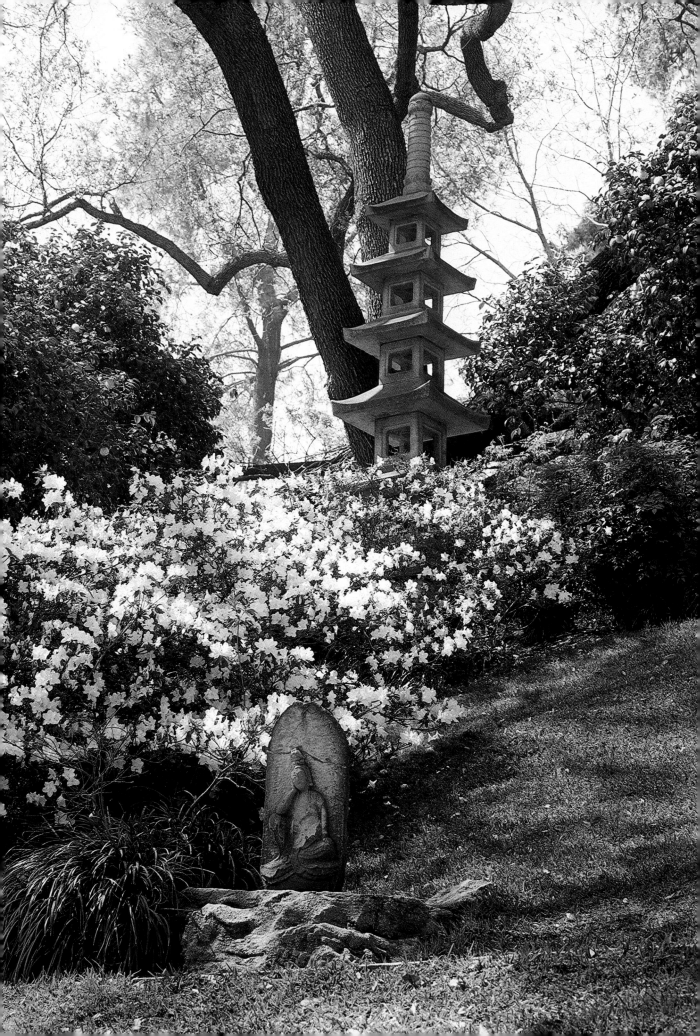

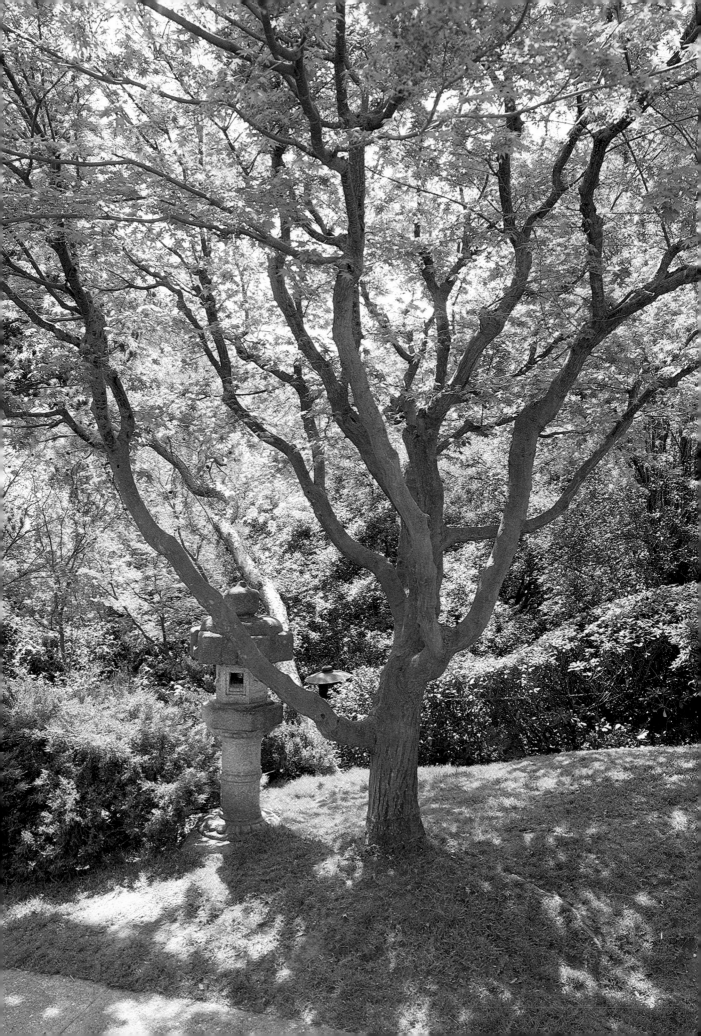

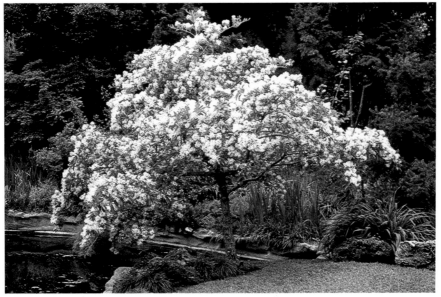

Every garden at the Huntington has some flowering trees. In June this Chinese fringe tree (*Chionanthus retusa*) dazzles visitors with its generous bloom.

◁ The green-leaved Japanese maple (*Acer palmatum*) is naturalized throughout the garden. Its changing patterns of light and shade delight the eye.

South of the Japanese House, the zigzag bridge crosses a dry landscape to reach the gate of the Zen Garden. The zigzag design traditionally frustrates evil spirits, which are believed to travel only in straight lines.

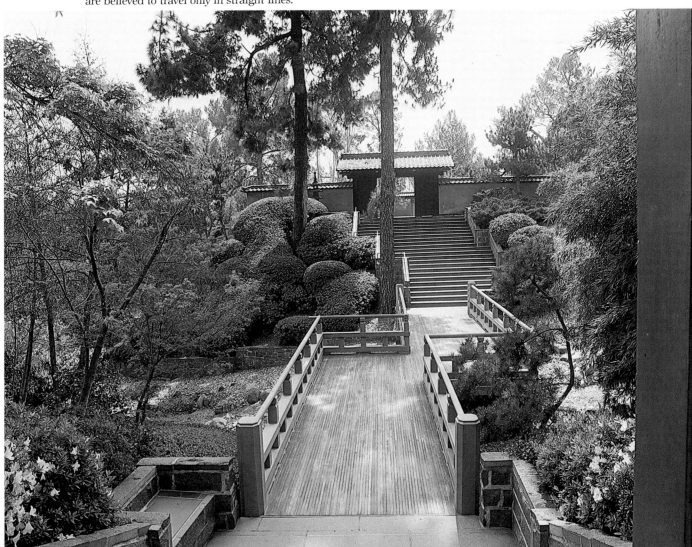

A collection of bonsai or dwarfed trees occupies a courtyard beyond the Zen Garden. This graceful cork elm (*Ulmus alata*) displays its glorious autumn foliage in miniature.

The Zen Garden of raked sand and gravel is a place for contemplation. The quiet, open expanse suggests a flowing stream, broken by a few large rocks and backed by shrubs. Here symbolic elements of nature invite the viewer to an exercise in spiritual awareness.

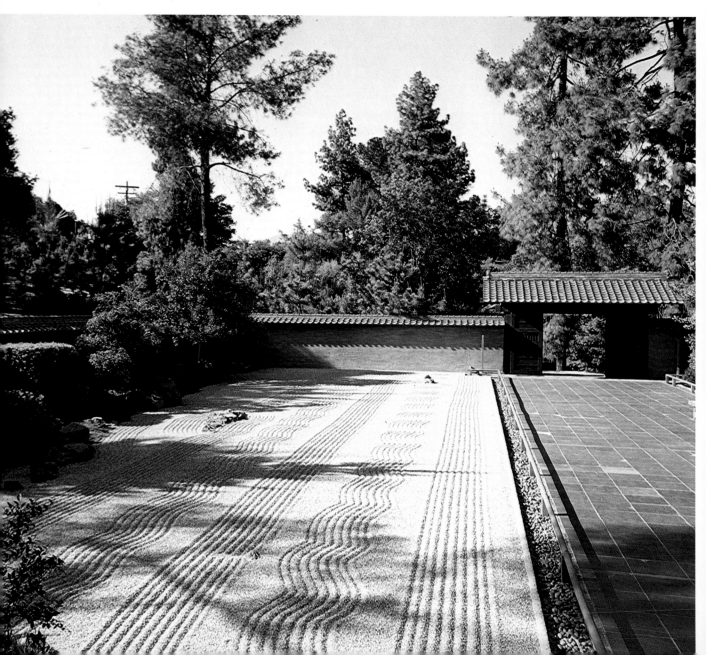

Another face: a portrait sculpture of a
Zen Buddhist priest in the Bonsai Court.

Sunlight and rain have
Fallen on his face and still
He meditates in peace.

These two fine lion-dogs guard the exit path
from the Zen Garden. Through the grove
of golden bamboo appears one last stone
lantern, its irregular form suggesting a stony
mushroom.

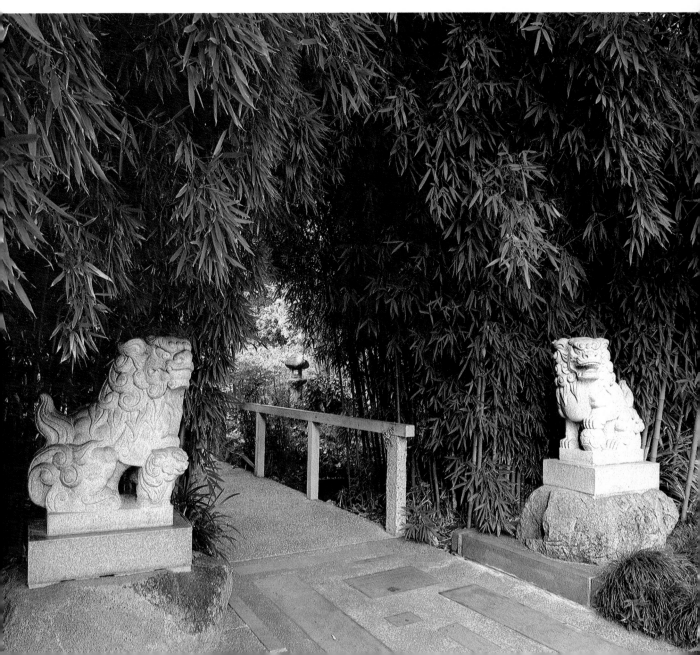

Brilliant colors come on strong in the Australian Garden. These pointed silvery bud-caps of *Eucalyptus macrocarpa* pop off to reveal scarlet tufts of bloom.

Soft puffs in spikes of gold cover this acacia in the winter months.

The seven Lily Ponds are awash with tropical and hardy waterlilies. The koi population ▷ stirs below, and a statue of St Francis appears to look gravely on.

Trees of the Subtropical Garden lift their color to the eye: here the jacaranda rivals the sky with a warmer blue. In the lower right, the blooms of the marmelade bush (*Streptosolen jamesonii*) change color as they age.

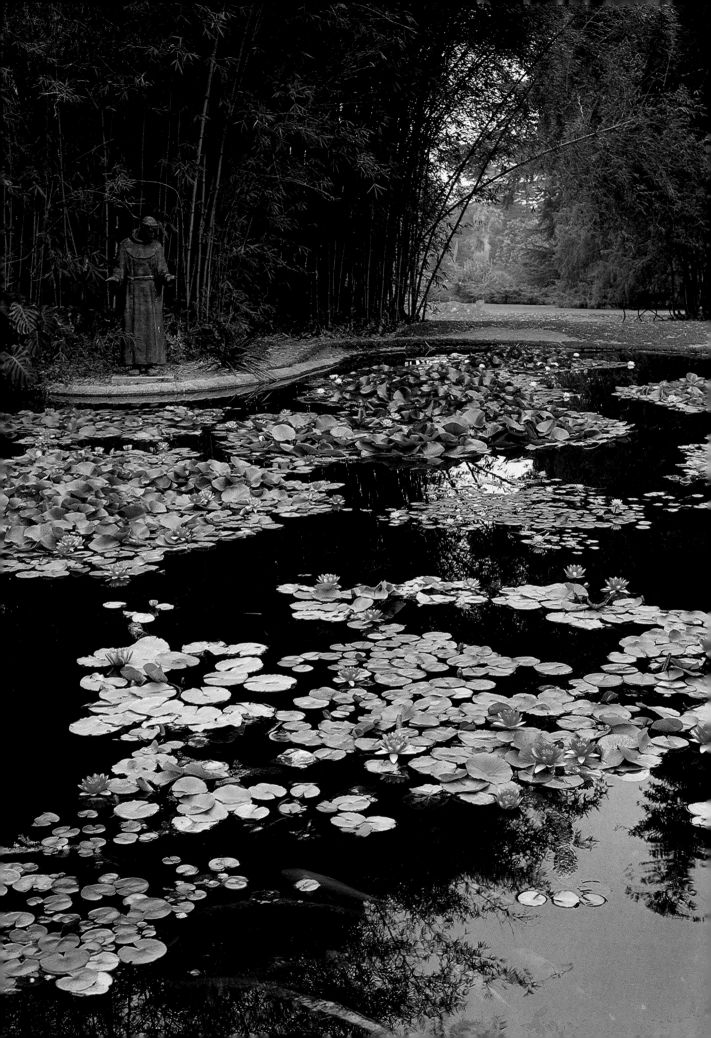

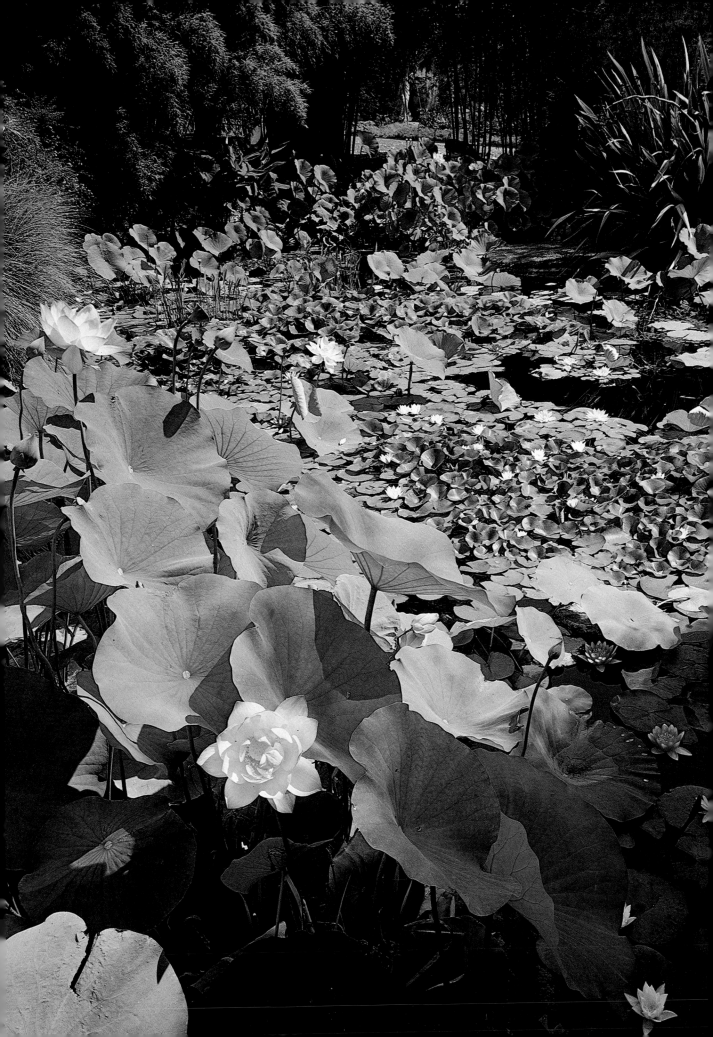

The ombu (*Phytolacca dioica*), a native of Argentina, stores water in its massive trunk and offers welcome shade on the dry Argentine pampas.

An exotic creature of the nearby Jungle Garden is the *Musa ornata*, a variety of banana.

◁ In a lower pond, the East Indian lotus (*Nelumbo nucifera*) lifts flowers and leaves high above its companion waterlilies.

The last of the ponds is bordered by iris and bamboo. Across the surrounding lawn grows a varied collection of rare conifers: redwoods, cypress, and deodar cedar.

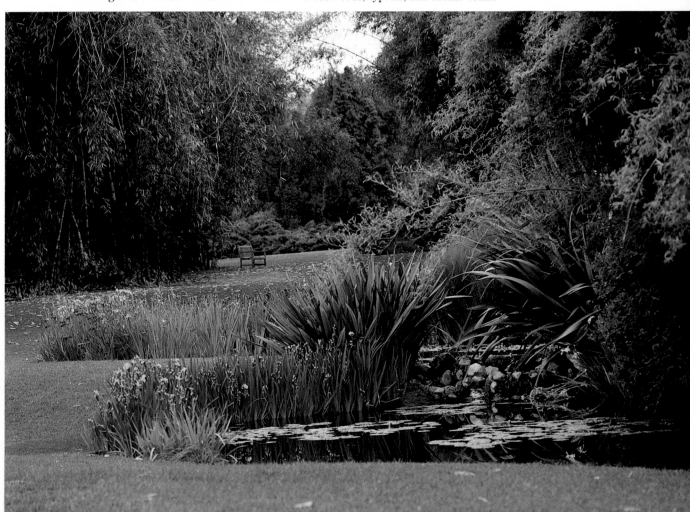

This cascade, dropping from the Jungle Garden to the Lily Ponds, artfully combines the rush of water, smooth gray stones, lacy ferns, darker green fronds, and the peppery scarlet of the bromeliads.

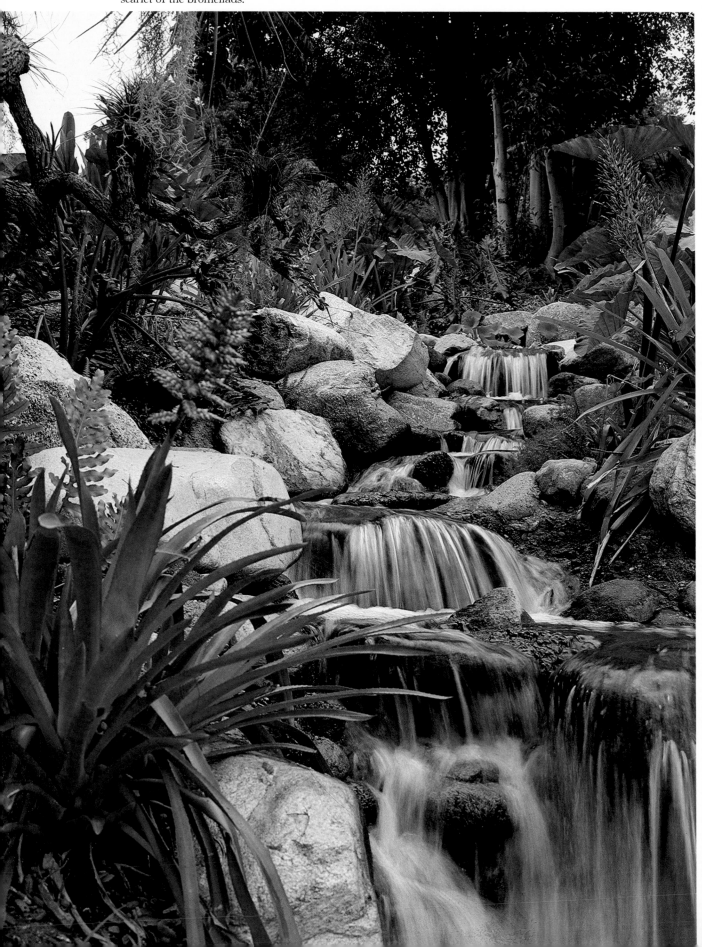

Tree ferns add their patterns to the canopy overhead.

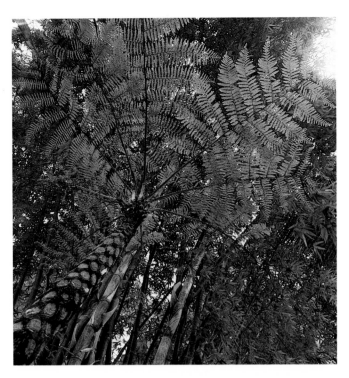

Pressing deeper into the Jungle Garden, the visitor reaches this most restful and inviting dappled shade.

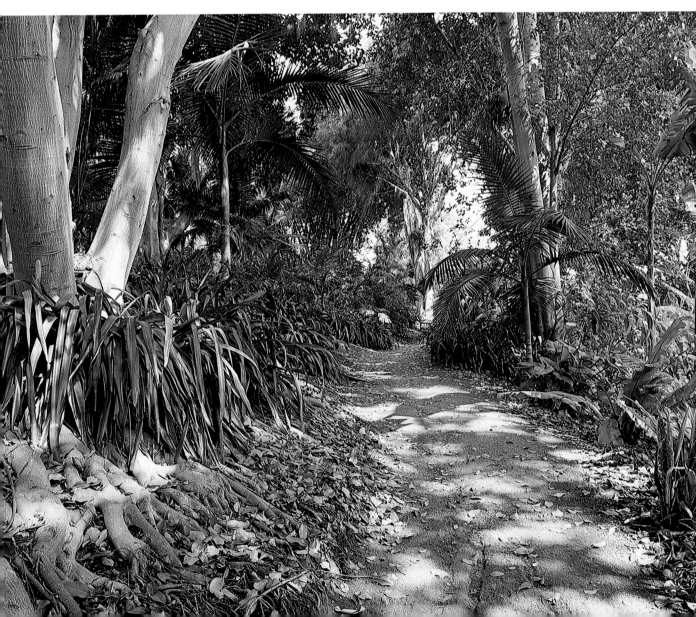

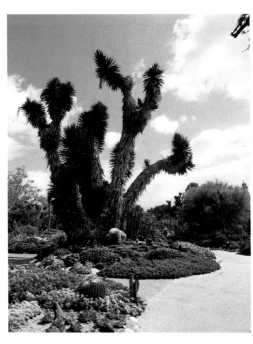

This shaggy giant of the Desert Garden is *Yucca filifera*, a native of central Mexico.

The golden barrel cacti (*Echinocactus grusonii*) seem to generate their own glow under a sunny sky. Behind: a spiky skyline of yuccas and palms.

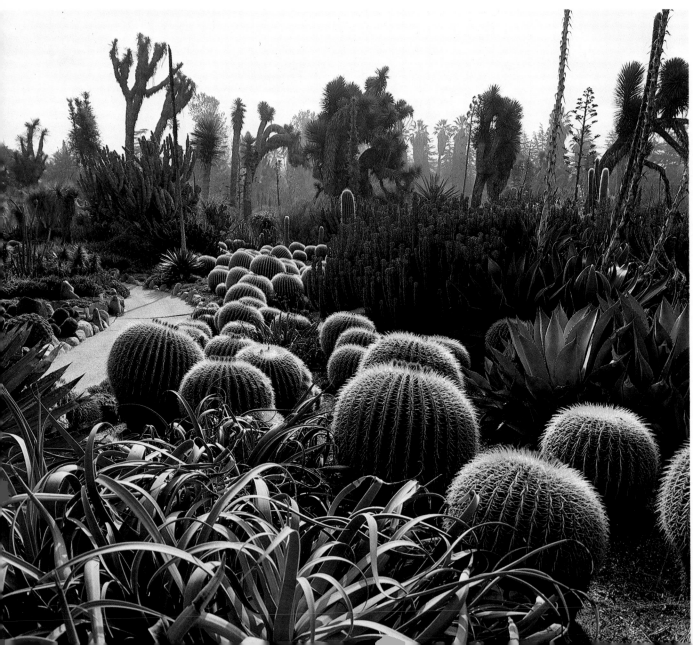

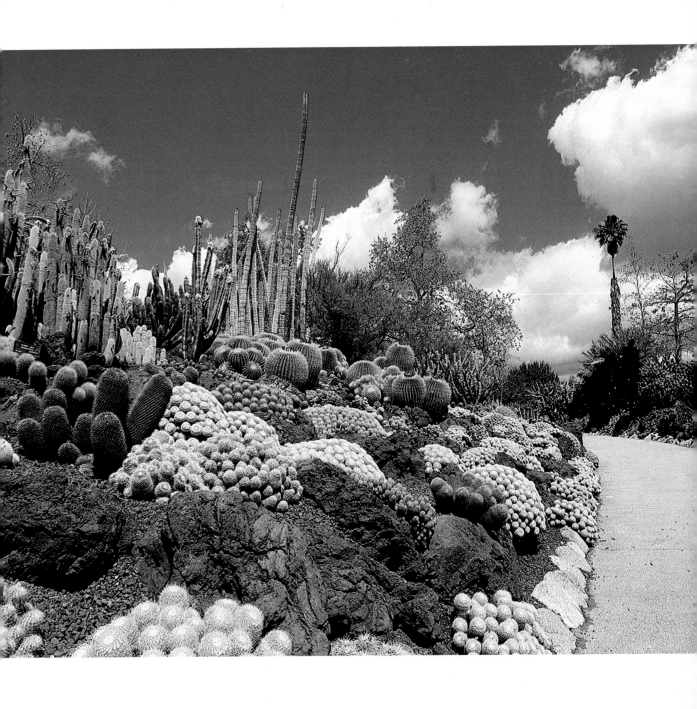

Sixty species of pincushion cacti (*Mammillaria*) may be seen in the Desert Garden's famous rockery. Mats and mounds of these plants grow in a setting of lava-rock, a spectacular sight all the year through.

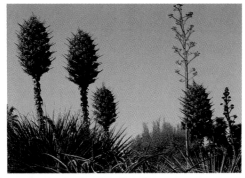

Two plants whose flower stalks make a dramatic showing against the sky: the *Aloe ferox* 'candelabrum' (African origins, member of the lily family), and the *Puya chilensis* (South American native, of the pineapple family).

The *Yucca whipplei*, known as "Our Lord's Candle", lifts tall flower stalks. In the left ▷ foreground are blooms of a dyckia, a South American bromeliad.

Creeping devil cacti (*Machaerocereus eruca*) and chalk-leaved live-forevers (*Dudleya brittonii*) mingle in the Baja California section.

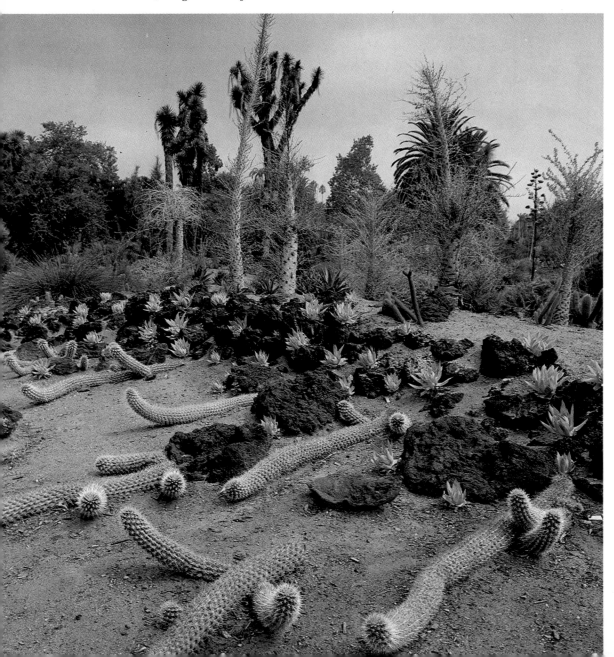

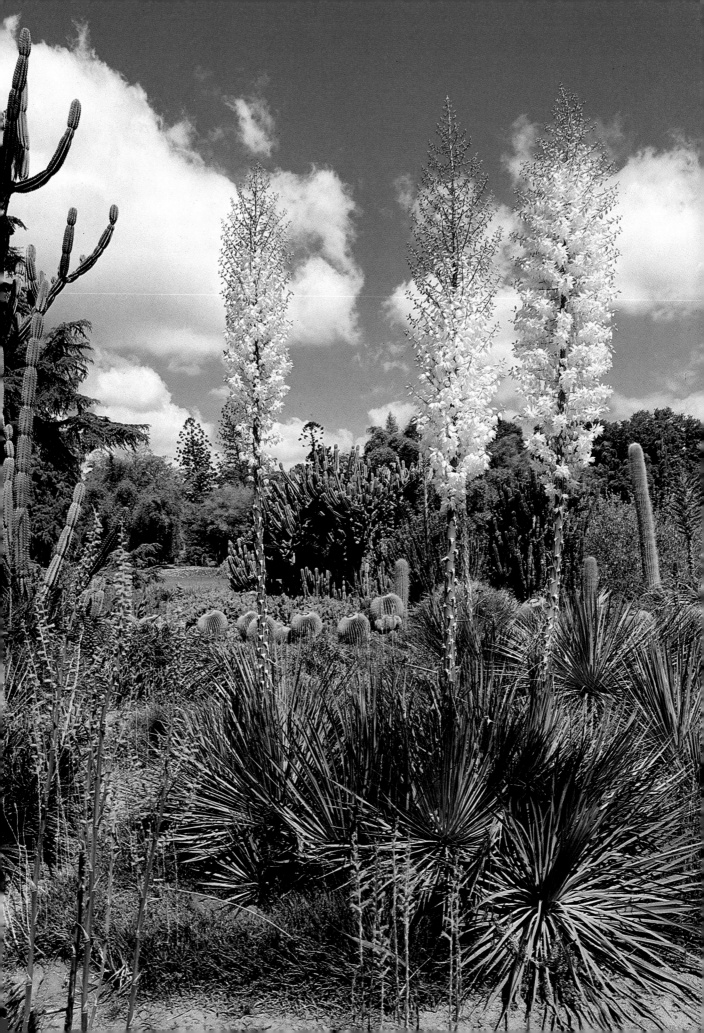

*Agave victoriae-reginae*

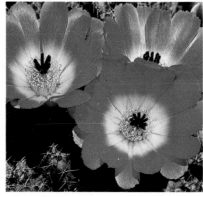

The hedgehog cactus (*Echinocereus pentalophus*).

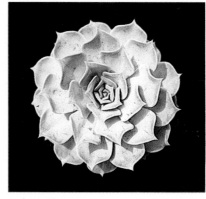

*Echevaria rayones*

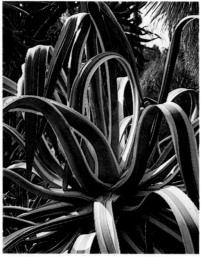

*Agave picta*

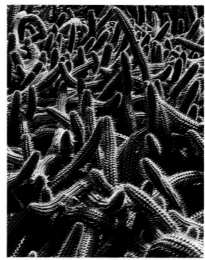

*Trichocereus thelegonus*

A South African coral tree (*Erythrina acanthocarpa*).

The crown of thorns euphorbia from Madagascar (*Euphorbia milii*, var. *splendens*).

Another nocturnal bloomer, an Easter lily cactus (*Echinopsis* sp.) from South America.

And, not to be outdone, the mammillaria with their tiny vivid sparks of bloom.

The night-blooming *Nyctocereus serpentinus*, ▷ known in Mexico as "queen of the night".

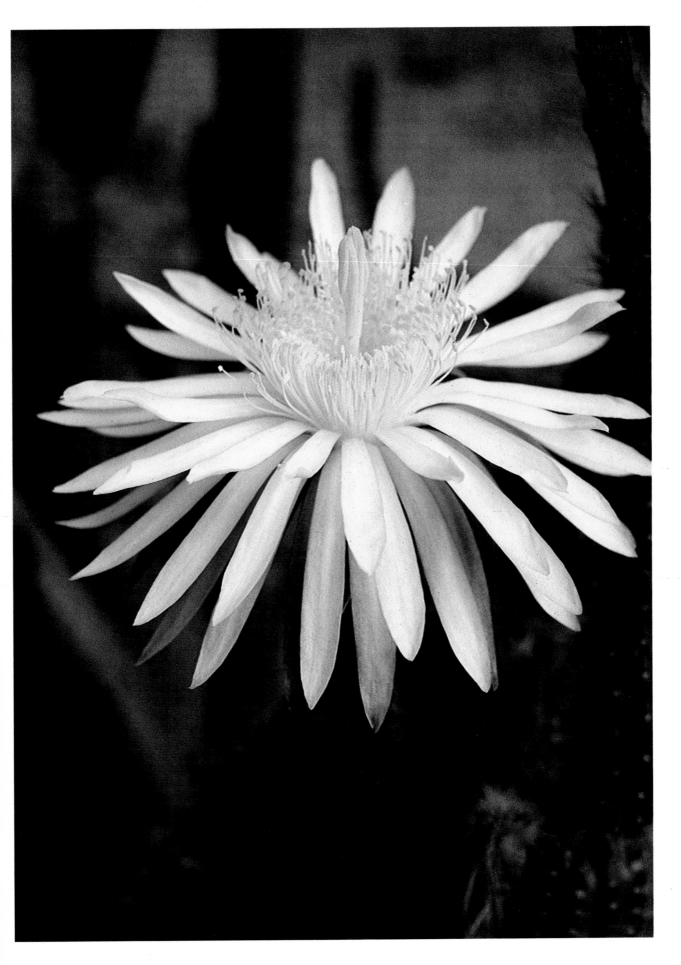

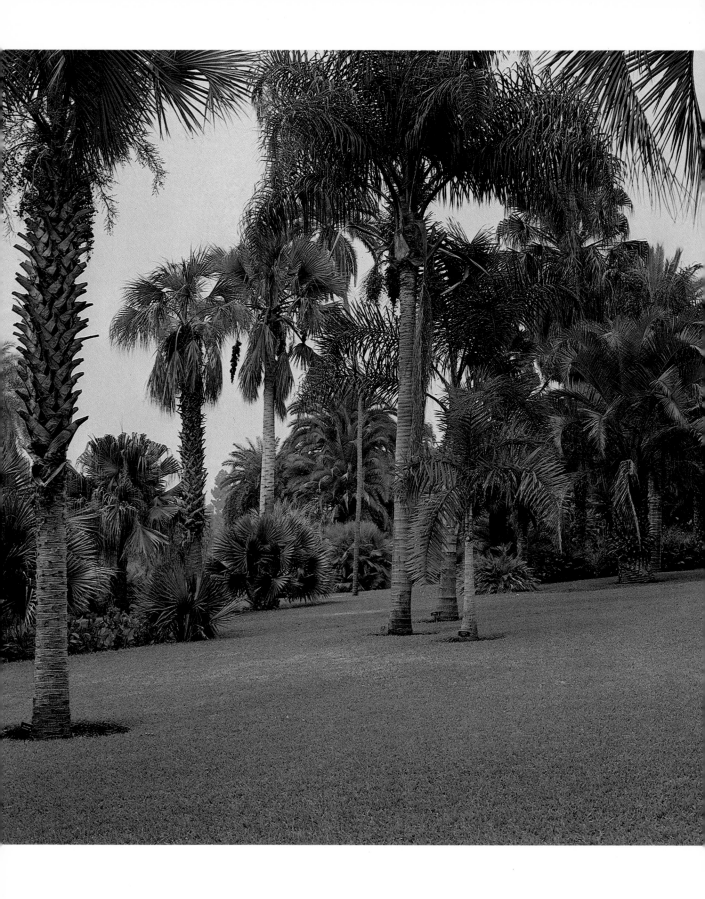

In the Palm Garden, the air always seems to be stirring among the ninety varieties of palms. Green lawns spread a generous carpet, and cannas add a spice of color.

The arboretum-style parking area contains many unusual mature trees, with flowering shrubs from around the world. Here, tall eucalyptus frame the view of a rare snowfall on nearby mountains.

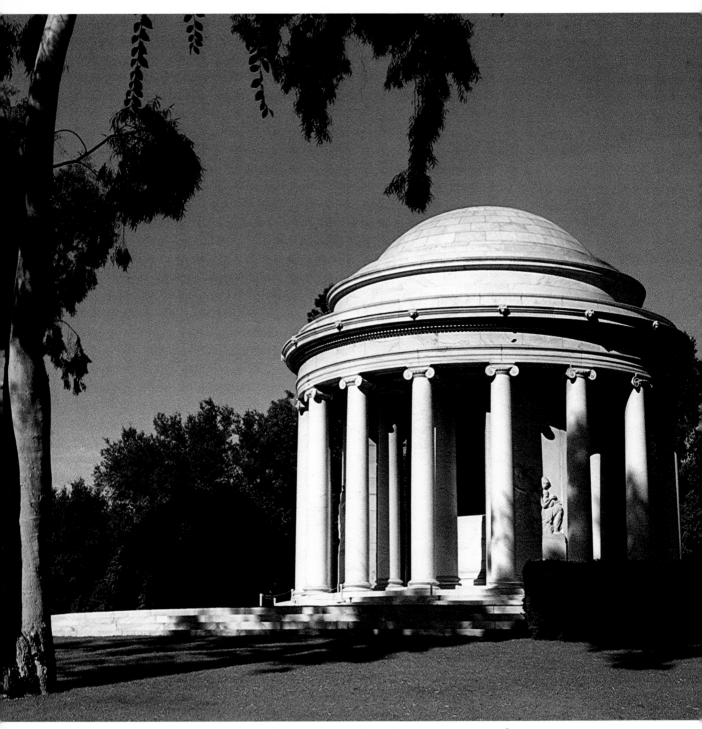

In this marble mausoleum on the grounds, Mr and Mrs Huntington are interred.

# Index

*Figures in italics indicate illustration pages*

The Huntington has introduced many new plants into cultivation, none more appealing than this *Tacitus bellus*, a native of Mexico.